W9-CUQ-214

Master Strokes
Watercolor

Master Strokes
Watercolor

A step-by-step guide to learning from the masters

Hazel Harrison

Sterling Publishing Co., Inc.
New York
A Sterling/Silver Book

Contents

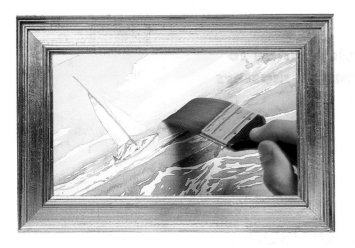

A QUARTO BOOK

Library of Congress Cataloging-in-
Publication-Data
Harrison, Hazel
 Masterstrokes. Watercolors: a step-by-
step guide to using the techniques of the
masters / Hazel Harrison
 p. cm.
 "A Quarto book"
 Includes index
 ISBN 0-8069-2427-6
 1. Watercolor painting—Technique. I.
Title. II. Title: Watercolors.
ND2420.H375 1999
751.42'2—dc21 98-47138
 CIP

10 9 8 7 6 5 4 3

ISBN 1-4027-2211-7

First paperback edition published in 2001
by Sterling Publishing Co., Inc.
387 Park Avenue South
New York, NY 10016-8810

Copyright © 1999 Quarto Inc.
Distributed in Canada by Sterling Publishing
c/o Canadian Manda Group
165 Dufferin Street
Toronto, Ontario, Canada, M6K 3H6

This book was designed and produced by
Quarto Publishing plc
The Old Brewery
6 Blundell Street
London N7 9BH

Senior editor Anna Watson
Text editor Ian Kearey
Art editor Sally Bond
Designer Tanya Devonshire-Jones
Illustrator Alan Oliver

Photographers John Wyand, Les Weiss,
 Martin Norris
Picture researcher Gill Metcalfe
Art director Moira Clinch
Assistant art director Penny Cobb

QUAR.MTW

Typeset in Great Britain by
 Central Southern Typesetters, Eastbourne
Manufactured in Singapore by
 Pica Colour Separation Overseas Pte. Ltd.
Printed in Singapore by Star Standard
 Industries (Pte.) Ltd

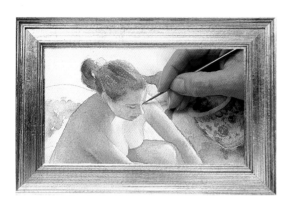

The nude in a setting

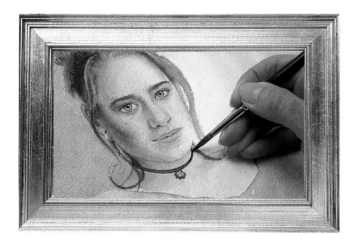

Portraiture

Painting flowers

Figures in landscape

Watercolor Techniques — 76

Introduction

The aim of this book is to teach you how to analyze the works of the great masters, thus gaining knowledge and insights that will help you in your work.

HOW THE BOOK WORKS

The core of this book is the central section, which focuses in detail on a series of master paintings, each of which has been chosen to illustrate a specific subject area, such as portraiture, figure painting, or landscape. The analysis of each master painting is followed by a tutorial, in which a contemporary watercolorist demonstrates how he or she treats a similar subject.

The teaching points gleaned from the master paintings and tutorials are cross-refered to the final section of the book, which explains individual watercolor techniques, each one illustrated with step-by-step demonstrations. The brief history of the watercolor medium at the start of the book, followed by practical advice on equipment and papers, provide a useful introduction to the medium.

"LEARNING FROM THE MASTERS" SECTION

The master paintings are looked at in detail over four pages, with captions and annotation explaining uses of color, composition and techniques. Certain sections of the works are shown in close-up detail to enable you to see the artist's methods clearly.

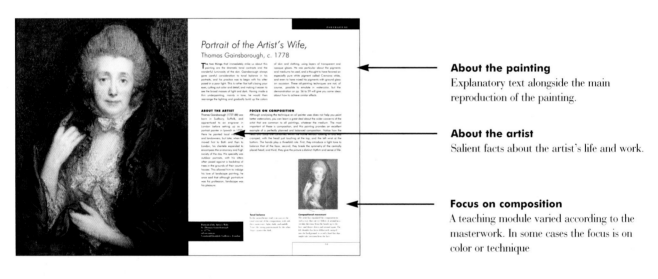

About the painting
Explanatory text alongside the main reproduction of the painting.

About the artist
Salient facts about the artist's life and work.

Focus on composition
A teaching module varied according to the masterwork. In some cases the focus is on color or technique

Equivalent colors
Suggestions for colors you might use if you wished to recreate the masterwork in watercolor.

Points to watch
Tips on how to approach the subject matter, and suggestions for overcoming common difficulties.

THE TUTORIALS

A contemporary watercolor painter shows how the lessons learned from the masterworks can be adapted and used in a individual way.

Step-by-step sequences
Shows how the painting is built up, from the planning stage to completion.

Introduction
Paragraph explaining the artist's way of working and, where relevant, the materials used.

The finished picture
Large color reproduction with caption and annotation.

Colors used
The artist's palette, giving you ideas on which colors to choose for a similar subject.

Techniques used
Refers you to the Watercolor Techniques section, where you can find additional information.

Extra teaching points
Leader lines help you to focus on specific points of interest.

"WATERCOLOR TECHNIQUES" SECTION

All the basic techniques used by watercolor painters today, plus some more unusual ones you may like to try out. Combines with the lessons learned from the masterworks to provide a complete painting course.

Gallery paintings
A selection of finished paintings featuring specific techniques.

CONCLUSION

Studying the work of the masters is a productive exercise, as it helps you to bring the all-important element of analysis to your own work. Even though some of the masterworks shown here are in oil, and your chosen medium is watercolor, the basic tenets of painting are the same whatever the medium used, and the essential lessons you learn from the book will help you to develop your art.

Artworks
Examples showing the finished effect of a technique.

Step-by-step sequences
Full-color demonstrations showing techniques in action.

Watercolor
The Medium

WATERCOLOR: Past and present

In some ways, watercolor can be seen as an older medium than oils. The tempera paint used for wallpaintings and panel paintings before the 15th century was a form of watercolor, but this fast-drying opaque paint had more in common with gouache or acrylic than with the transparent, free-flowing watercolor which we use today.

Watercolor comes of age

The development of watercolor techniques goes hand in hand with the growing recognition, during the 18th and early 19th centuries, of landscape as a subject in its own right. Earlier artists, among them Albrecht Dürer, had made use of watercolor, as had many of the botanical artists of the 16th and 17th centuries, but it was not until the group of landscape painters known as the English School took up the medium that its full potential began to be explored.

The artist Francis Towne used a technique of flat washes over a pen-and-ink outline, an extension of the topographical artists' or illustrators' practice of using watercolor to "color in" a drawing. Another important figure was Paul Sandby, who also worked in oils, and combined transparent and opaque watercolor, or body color, in his work. But the real giants of the medium were John Sell Cotman and Thomas Girtin, who worked at the turn of the 18th and 19th centuries. Cotman established what is now known as the classic watercolor technique, working from light to dark and building up form in a series of flat, overlaid washes that create a geometric, semi-abstract pattern (see p. 20). Girtin, who began as a topographical artist, soon abandoned the tinted-drawing style to produce works in which strong colors were laid in broad washes to convey wonderful effects of space and atmosphere.

Born in the same year as J. M. W. Turner (1775), Girtin sadly died in his late twenties, but his contribution to landscape painting was recognized by his great contemporary, who said that "If Tom Girtin had lived, I should have starved." In fact this seems unlikely, since Turner himself produced, in addition to his great oil paintings, a number of watercolors of astonishing depth and richness. He was one of the first to appreciate the immediacy of the medium and its speed of application,

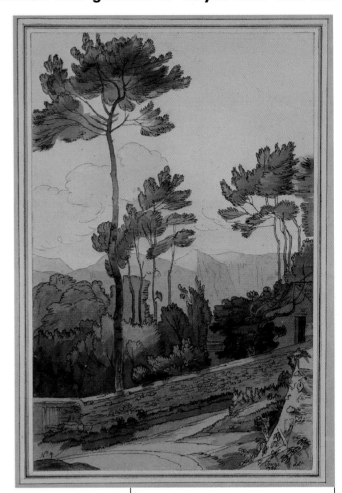

Ambleside,
by Francis Towne
Watercolor on paper

and among his most powerful works are a series of rapid, on-the-spot sketches recording the burning of London's Houses of Parliament in 1834.

Changing styles

When the very precise and detailed style of the Pre-Raphaelites, who looked back to the past for their inspiration, came into vogue in the mid-19th century, watercolor began to be used in a different way, no longer in broad, free washes, but more like the tempera paintings of earlier times, utilizing small brushstrokes, sometimes stippled with the point of the brush or in fine hatching strokes. William Henry Hunt and John Frederick

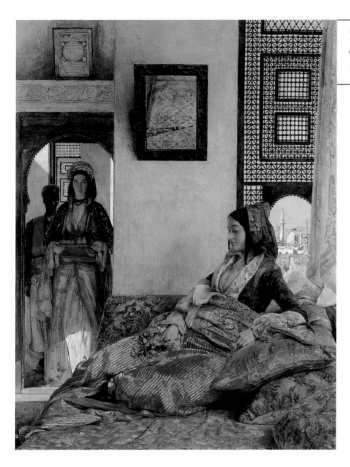

Life in the Harem
by John Frederick Lewis
Watercolor on paper

the majority of amateurs, and is strongly favored by the buying public. A noticeable trend in modern watercolor painting is a willingness to experiment by mixing watercolor with other media, combining opaque and transparent paint, and exploiting the unpredictability of the medium, working wet in wet (see p. 92) and encouraging semi-accidental effects such as backruns (see p. 78). Turner, always a pioneer and never bound by rules, was the first to work in this uninhibited way, and we can learn much from his example as well as from the exponents of the more controlled, classic technique.

Lewis are both examples of this new/old approach. The latter, who specialized in Middle Eastern scenes with richly clad figures, built up wonderfully rich, jewel-like colors and an amazing degree of detail in this way, but in the end found the sheer effort too great for the financial reward, and returned to oil painting. Edward Burne-Jones rejected the classic technique even more thoroughly, using body color (see p. 79) and sometimes rubbing in dry color to achieve the depth and brilliance he sought.

By the late 19th century, watercolor had ceased to be so much of an English specialty. On the other side of the Atlantic, the American painter Winslow Homer was producing paintings that rival the work of Cotman in their expressive qualities and mastery of the medium. In Europe, the Impressionist "revolution" had taught the value of the spontaneous and rapid sketch, for which watercolor was the ideal medium, and the example of artists such as Cotman had shown that a work done in watercolor could rival any work done in oils.

From being seen as the poor relation of oils, watercolor has fully come of age in the 20th century. It is the preferred medium of many professional artists and

Grapes and Bowl
by Shirley Felts
Watercolor on paper

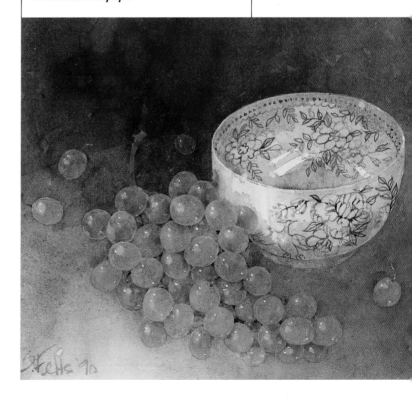

Watercolor and Gouache

The term watercolor is usually reserved for transparent colors sold in small tubes or pans, but gouache is also water-soluble, as is acrylic paint, which can lead to confusion. For example, although manufacturers always list the three types of water-based paint separately, art galleries and books sometimes lump them together, so that you may see a largely opaque gouache or acrylic painting described as "watercolor" or "watercolor with body color," the latter being a term for opaque paint.

Gouache paint is simply an opaque version of watercolor, made in a similar way, and since the two types of paint are often used in combination in one painting, they are discussed together here.

Transparent watercolor, like all the painting media, consists of pigment, a liquid, and a binding medium, in this case water and gum arabic. Watercolors also contain glycerine and a wetting agent, such as oxgall, to make the paint malleable and prevent it from drying out, and usually also a fungicide. Gouache paints have a larger glycerine content, which makes them more readily soluble than watercolors, and are made opaque by the use of a higher proportion of pigment, or by the addition of extenders such as precipitated chalk.

Different characteristics

Because watercolors are transparent, you cannot lay light colors over dark ones. Instead, colors and tones are built up gradually, working from light to dark. In classic watercolor technique, any highlights are "reserved" by leaving them as white paper and painting around them; the paper itself plays an important part, because white reflects back through the thin layers to produce the luminous quality typical of the medium. This can easily be sacrificed if you lay on too many layers of paint, so it is best not to exceed three layers, or four layers at the most for the darker colors.

Gouache, being opaque, will

cover the paper fully, so you can work on colored surfaces and build up from dark to light. But it is still wise to avoid putting on too many layers of paint, especially if you are using it thickly. Because gouache is so easily soluble, each new layer has a tendency to dissolve the one below so that the two mix, causing muddy, dirty-looking colors. The best way to work is to begin with well-thinned paint and gradually work up to more opaque applications. In the later stages, thick paint can be used in a dry-brush technique (see p. 80) to avoid stirring up the colors beneath.

Transparent and opaque

If gouache is thinned with water, and no white is used in the color mixture, it looks and behaves very much like watercolor, allowing you to achieve the same transparent effects. You can also vary the consistency of the paint in the same picture, contrasting transparent and opaque passages. Gouache and watercolor can be used together in just the same way; artists often use a little white gouache to reclaim highlights in a watercolor painting, or mix white in with watercolor for a feature they want to emphasize. As long as you use the white sparingly and avoid over-thickening the colors, you will retain the translucent watercolor look.

OVERLAYING COLORS

This shows the effect of laying watercolor over watercolor, wet on dry. The lemon yellow shows through the transparent cobalt blue, giving a soft green color.

Yellow gouache does not show through when blue gouache is laid over it, wet on dry. At the bottom of the blue brushmark you can see some muddying of color where the yellow gouache has dissolved.

The brush stroke on the left shows cobalt blue watercolor with a touch of white gouache added, laid over dry yellow watercolor. On the right, the contrasting effect of laying gouache over watercolor is shown.

Papers for Watercolor

It can be confusing buying watercolor papers, because they are listed under different manufacturers' names as well as different types and weights. However, excluding the hand-made papers available only from specialist suppliers, the choice boils down to three main types of surface: Rough; Cold-pressed (also known as Not, short for "not hot-pressed"), and Hot-pressed, or HP (smooth). The most commonly used surface is Cold-pressed, which has a medium-textured surface, but it is important to experiment with different papers, because the texture and degree of absorbency affect the way the paint behaves. Once you have found a paper you like, stick with it, because you will find that there are considerable variations from one manufacturer to another, according to the raw materials used and the method of processing.

Paper is made in different weights, expressed either as pounds per ream or as grams per square meter (gsm or gm²). Weights range from 300lb (600gsm)—almost like board—to about 60lb (120gsm), which is very flimsy. Unless you work very dry, or are simply doing small, quick sketches, any paper lighter than 200lb (410gsm) should be stretched before use (see box opposite), or it will buckle under the water content of the paint.

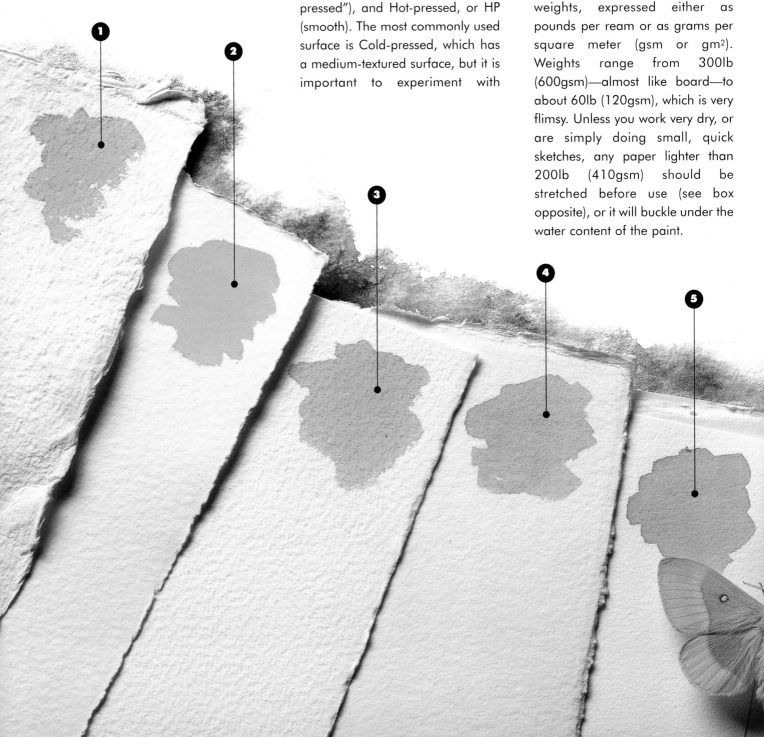

Toned paper

Although white paper is the usual surface for watercolor work, some of the 18th- and 19th-century artists worked on toned paper, usually deep cream or light brown, and this is now available from at least one manufacturer. It is obviously not suitable for any painting in which you want to reserve white-paper highlights, but it is ideal for gouache and watercolor-and-gouache mixtures, where the highlights are done in opaque paint. You will find information about toning your own papers on page 89 of the Techniques section.

In general it is easier to use a colored surface for opaque paints, because this provides a mid-tone, allowing you to work up to the lights and down to the darks. You can also choose a color that blends with or contrasts with the subject, a helpful aid in judging colors in the early stages. Pastel papers, made in a wide range of colors and tones, are suitable for gouache work, but the thinner ones will need to be stretched unless you work very dry.

STRETCHING PAPER

There are two ways to stretch paper. The first is to stretch the paper right around the edges of a board and tape it at the back, and the second, shown here, is to tape it onto the front. This is the easiest, and gives you more choice of size. For the first method, you would either have to work always to the same size, or have several drawing boards in different sizes. In this case you need only have one board, a minimum of 2in (5cm) larger than the piece of paper. It is essential to use the brown gummed tape known as gumstrip rather than cellophane tape or masking tape, neither of which will accept water.

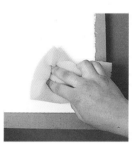

1 Soak the paper
Wet the paper on both sides, either by immersing it in a bath and then shaking off the surplus, or by using a sponge, as here.

2 Wet the gumstrip
Cut a piece of gumstrip for the first long side and damp it by passing it over the sponge.

3 Stretch the paper
Stick the gumstrip down, using the sponge to smooth it out and make sure it adheres properly. Repeat for the other three sides.

Watercolor Equipment

KEY

1 Round brushes in (from left to right) sizes 00, 3, 5, and 11
2 Flat brushes in widths $5/8$" (16mm), size 12, and $1/8$" (3mm)
3 Hake brush for washes
4 China palette
5 Hogs hair (bristle) brush
6 Plastic palette
7 Small natural sponge
8 "Stay-Wet" palette
9 Liquid frisket (masking fluid)
10 Gum arabic
11 Ox-gall liquid

Apart from the paints themselves, the most vital pieces of equipment are your brushes, and you should choose wisely and look after them well. You will not need a huge selection, because a good brush that comes to a fine point can be used for both broad and detailed work.

Brushes

The best brushes are Kolinsky sable. These are very expensive but will last a lifetime if looked after, so consider investing in one medium-sized sable. There are various alternatives on the market, ranging from nylon to various sable-and-synthetic mixtures. Most of these are perfectly adequate, and are used by some professional artists, but none of them hold the paint or retain their points quite so well as sables.

There are two main shapes of brush for watercolor, round (pointed) and flat, and they are made in a range of sizes, from number 0 or sometimes 00 (tiny) to 12 or 14. Other useful brushes are mops, usually made of soft hair such as squirrel, for broad washes and wet-in-wet effects, and riggers. The latter are especially fine, long-haired brushes, suitable only for linear detail, traditionally used by marine artists for painting rigging.

The same brushes can be used for gouache, but for thick applications most artists prefer oil-painter's bristle brushes or the tough, long-handled synthetic brushes primarily sold for acrylic painting.

Palettes

Watercolor paintboxes containing pans of color incorporate their own palettes, but these do not always provide enough space for mixing, so you may need an auxiliary palette. If you use tubes rather than pans, you will need a palette with recesses to squeeze the colors into and shallow "wells" to keep the mixed colors separate. There is a wide choice of such palettes, made both in china and plastic, and you

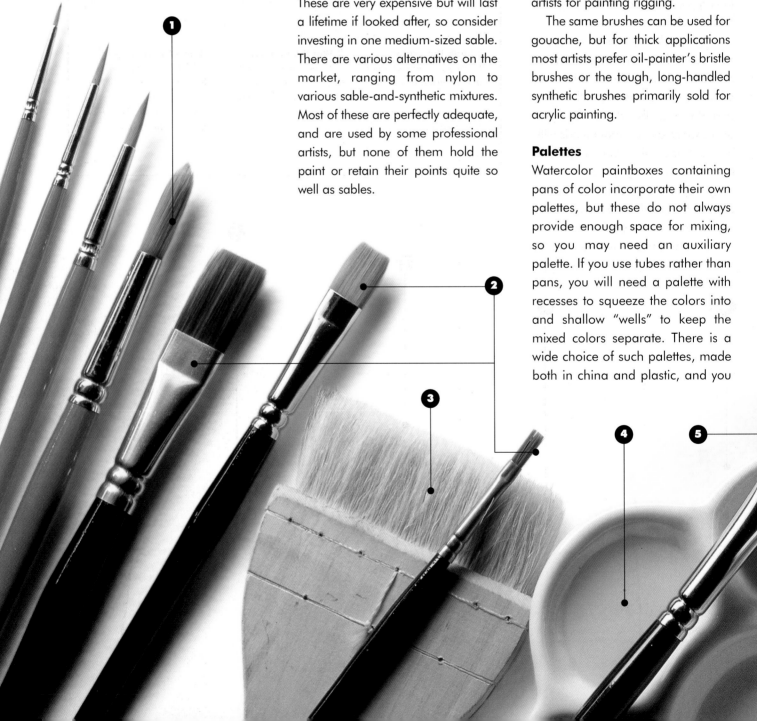

can also buy small, circular dish palettes that can be stacked one on top of another when not in use.

Any of these can also be used for gouache, but a disadvantage of gouache is that it dries out rapidly on the palette, making it difficult or even impossible to release the color. There is a special palette sold for acrylic painting tradenamed "Stay-Wet," which can also be helpful for gouache. This is a deep plastic tray that comes with a transparent lid and sheets of absorbent paper and "membrane" paper. A little water is put into the tray, followed by the absorbent paper and then the membrane paper, on which the colors are laid out. Sufficient moisture seeps up to keep the paints from drying, and if the lid is put on after a working session they will remain workable for many days.

Mediums
As water is the primary medium for watercolor work, you do not strictly need anything else, but there is one medium that is useful on occasions. This is gum arabic, which is used in the manufacture of watercolor and can also be mixed with the paints on the palette. This has the effect of giving the paint more body and a slight gloss without affecting its transparency, so that it holds the

marks of the brush and becomes more controllable. It is also an aid to the lifting-out technique (see p. 83). Never use gum arabic neat, as it may cause the paint to crack. It should be mixed with water, to a proportion of one part gum arabic to three parts of water, or less.

Another medium for watercolor work is oxgall. This is a water-tension breaker that has the opposite effect to gum arabic, helping the paint to flow smoothly.

Other equipment
A small natural sponge forms part of most watercolorists' kits. This can be used for washing off paint when a mistake has been made, or for softening edges, as well as for laying washes and lifting-out techniques (see pages 90 and 83). Another standard item of equipment for many artists is liquid frisket (masking fluid), the easy way to reserve highlights (see p. 85).

Finally, you will need pencils for underdrawing (see p. 90), boards for supporting the paper, and last but not least, receptacles for holding water. For indoor work, jam jars can be used, but these are uncomfortably heavy for outdoor painting. A variety of light, plastic water containers is available, including a type with a non-spill lid.

The Dismasted Brig,
John Sell Cotman, undated

Two things immediately strike us about this painting: the sureness of technique and the modernity of the treatment. The popular style in watercolor painting during the later 19th century was characterized by a high degree of detail achieved with many tiny brushstrokes; such paintings are much sought after by today's collectors. But Cotman is a "painters' painter," who took a much bolder and broader approach, editing out unwanted detail to express the essence of what he saw, and making his varied and exciting brushwork an integral part of the composition, much as the Impressionist and Expressionist painters did over a hundred years later. This painting is a perfect example of making "less say more." As in many of Cotman's works, he used broad, bold, but carefully controlled washes to build up shapes of almost geometrical simplicity that give

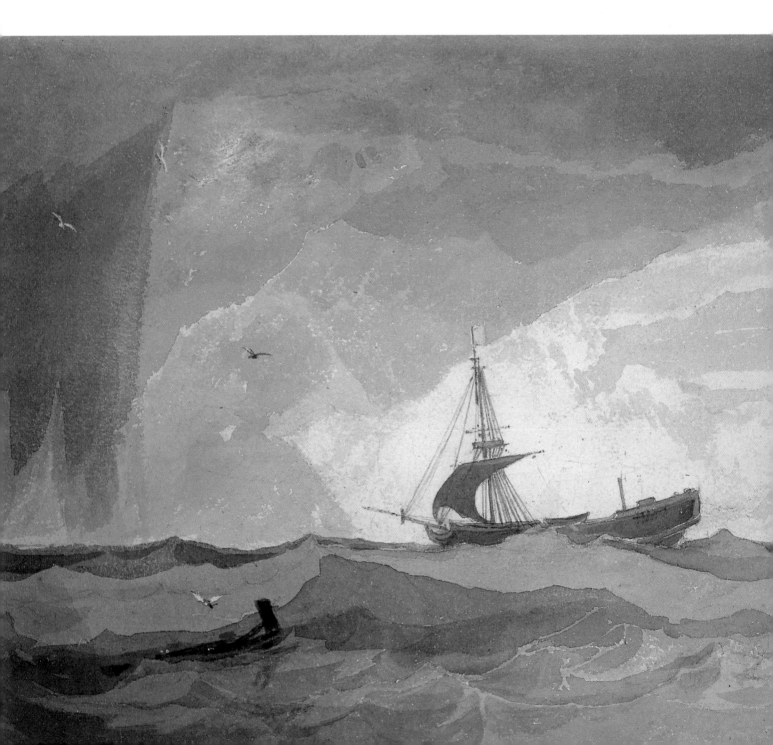

the painting a strong abstract quality, as well as being a powerful evocation of the subject matter. The composition is masterly, with the lovely, curving shape of the boat in semi-silhouette against the bright area of sky, and framed by the dark clouds. The angular shape of the large wave in the foreground balances that of the boat's sail, and leads the eye up to the focal point.

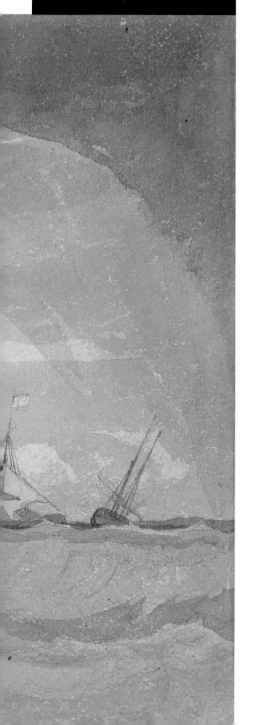

The Dismasted Brig,
by John Sell Cotman (undated),
watercolor,
British Museum, London.

ABOUT THE ARTIST

John Sell Cotman (1782–1842) was the son of a merchant in Norwich, and became one of the leading figures in the Norwich Society of Artists, now known as the Norwich School, a group of landscape painters who exhibited regularly from 1805 to 1825. In 1798 the young Cotman left his home town for London, where he worked as a copyist for Dr Munro, a wealthy collector and amateur artist, who helped and encouraged many of the young watercolor painters of the day, including J. M. W. Turner and Thomas Girtin. The artistic climax of Cotman's career was in his early twenties, when he made a series of superb watercolors of Yorkshire landscapes, but although these are much admired today, they did not sell well, and Cotman was forced to accept various posts as drawing master to the daughters of the aristocracy. Throughout his life he was prone to acute bouts of depression and uncertainty about the merits of his own work, and in later life he tried to emulate the vivid coloring of younger artists whose work he admired, using a form of semi-opaque watercolor made by mixing pigment with rice-paste.

EQUIVALENT COLORS

If you were to try to recreate the colors of the original painting in watercolor, the following colors would be useful as a basic palette:

 Indigo: sky, water and boats

 Raw sienna: water and boats

 Burnt umber: mast in water

 Cadmium red: mast in water

POINTS TO WATCH

The golden rule when painting water in movement, whether waves, waterfalls, or the eddies and ripples of a stream, is not to overwork. This is especially important in watercolor painting, as it can lose its freshness so quickly. The trick is to simplify, as Cotman has done, looking for the main shapes and patterns, rather than trying to recreate every tiny wavelet or ripple, which may make the painting look muddled and fussy. Take care also to relate the water to the sky so that they hang together in terms of color. Water always reflects the sky color in places but often has color of its own, caused by peat, suspended vegetation, or algae in the case of the sea.

Echoing shapes
The sky is related to the water not only through color—the gray-blue and gray-green are harmonizing colors—but also through shape echoes. This cloud is very similar in shape to the main wave, making a visual link between the two areas. You can see similar shape echoes elsewhere in the painting.

Dramatic effect
The arch of dark cloud that runs right over the top of the painting and down each side is vital to the composition, framing the bright sky and boat. Cotman has deliberately chosen a one-dimensional treatment very much like a stage setting, rather than attempting to give form to the cloud.

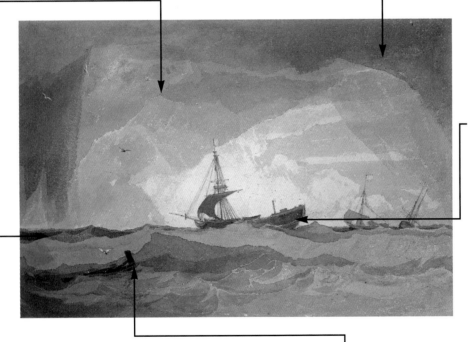

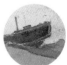

Color unity
The color scheme of the painting is muted, in keeping with the subject, relying mainly on tonal contrasts for dramatic emphasis. Any departure from the overall gray-blue and gray-green color theme in this central area would have destroyed the unity of the composition, so the color chosen for the boat is no more than a darker version of the sea color.

Reflected color
The sea is often darker at the horizon, reflecting more of the sky, while the mass of moving water nearer to the viewer retains much of its own distinctive color. The movement of sea water churns up the algae and vegetation, as well as providing less surface for reflection, giving a stormy sea its distinctive greenish tinge.

Selecting detail
Before you reject a detail in the interests of simplification, ask yourself whether it may help the composition or the "story" the picture is telling. The broken mast amid the waves does both, providing a foreground balance for the boat, as well as focusing attention on the plight of the stricken boat. The questing seagull adds to the atmosphere of the painting.

FOCUS ON TECHNIQUE

Cotman was one of the greatest exponents of what is now known as the "classic" watercolor technique, that of building up a painting with a series of carefully controlled flat washes, overlaying colors wet on dry (see p. 93). He never used wet-in-wet methods—these were not current in his day—and until his later life he avoided using body color (see p. 79), preferring instead to exploit the transparent qualities of the medium.

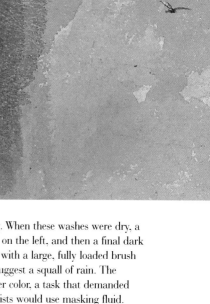

Overlaid washes (right)

This area of sky was done in several stages. Working on cream paper, two blue-gray washes were laid over one another for the lighter area of cloud on the right, leaving small lines and specks of the paper color showing. When these washes were dry, a darker one was laid over the area on the left, and then a final dark wash was made, the color put on with a large, fully loaded brush and dragged down the paper to suggest a squall of rain. The seagulls were reserved as the paper color, a task that demanded considerable skill; today, most artists would use masking fluid.

Using the paper color (left)

In the bright central area, the paper color comes into its own, and has been left largely uncovered, save for a few light brushmarks of pale blue applied fairly dry so that the color has caught only on the top grain. This gives a slightly mottled effect that captures the softness of the cloud, and contrasts with the flatter washes used for the patch of clear sky on the right and the gray clouds above.

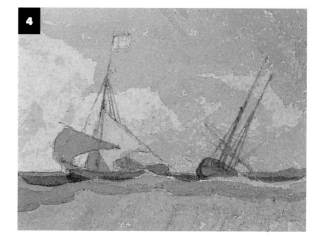

Painting waves (below)

Strong shapes, deep tones, and positive definition were needed in this foreground area, to provide a balance for the focal point of the boat. A light gray-green wash was laid over the whole sea area, and then the main triangular shape of the wave was established with a flat mid-tone wash, followed by a slightly darker one. In the immediate foreground, shaped brushmarks were laid side by side and over one another, with the tops of wavelets suggested by the little lines of the original pale wash left uncovered.

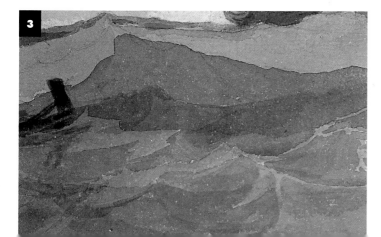

The importance of drawing (above)

For a painting like this, worked wet on dry with the highlights reserved, pre-planning is essential, and the artist made a careful outline drawing of the boats; you can still see the pencil marks around the edges of the sails. The rigging of the boat was "drawn" in paint over the sky in the final stages, probably using the type of small, thin, long-haired brush now known as a rigger.

TUTORIAL: Painting Water

Jason Skill's painting, "Sailing off Tynemouth," is less dramatic than the Cotman painting featured on the previous pages, but it is full of atmosphere, with the quiet color scheme and broad, decisive brushstrokes evoking the feeling of a windswept sea under soft evening light. Like Cotman, Skill has used the shapes made by the waves and clouds as a compositional frame for the boat, with the large foreground wave forming strong diagonals that balance that of the yacht's sloping mast. He is working on smooth (Hot-pressed) paper, primed with size to reduce its absorbency.

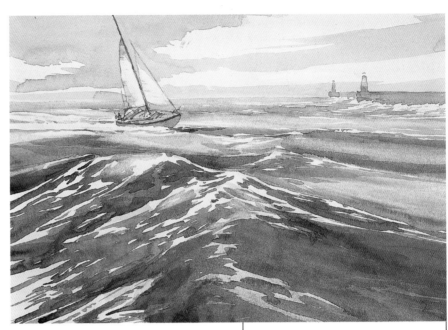

Sailing off Tynemouth, by Jason Skill

COLORS USED

 Permanent rose

 Lemon yellow

 Raw umber

 Cobalt blue

 Cadmium red

1 The color of the light (left)
After deciding on the composition through a series of quick sketches, the boat was drawn in with pencil. The first stage of the painting process is to establish the colors of the evening light. Under such lighting conditions there are no true whites, so the paper is "knocked back" with an overall wash of lemon yellow and rose red, which is left to dry and then strengthened in places.

TECHNIQUES USED

Brushwork page 80
Lifting out page 83
Washes page 90
Wet on dry page 93

2 Limiting the colors (right)
Because the color scheme of the painting is to be kept gentle and harmonious, with no obvious contrasts, the artist uses the same colors in mixtures throughout. For the lighthouse and harbor wall he adds cobalt blue to the red/yellow mixture, and for the sea he increases the proportion of red, deepening the color toward the foreground.

3 Reserving highlights (right)
The way the wave is painted demonstrates considerable skill in handling the medium, as the "negative shapes" must be reserved as the paper color, with the edges kept sharp and clear. Using the same mixture as before, but with more blue, the artist makes delicate strokes with the very tip of a large sable brush and broader strokes with the whole of the brush.

4 Warm and cool colors (left)
Now a warmer color, containing more red and yellow than previously, is taken over the nearest part of the wave to bring it forward in space. Because of the smooth surface of the paper, the paint puddles slightly and forms backruns. This can be effective, but later in the painting the artist decides to wash off some of the color (see step 12).

5 Controlling the paint flow (right)
With the sea now well established, the artist turns his attention to the sky, taking washes of blue-gray carefully around the sail. To soften some of the edges, he removes the pools of paint that form at the base of the washes, using the point of a damp brush to soak up the surplus color.

6 Critical assessment (below)
The painting has now reached the halfway stage, and the artist needs to consider what to do next. The broad brushstrokes he uses have run over the edge of the paper onto the masking tape, making it difficult to keep track of the overall composition, so he frames the picture with strips of white paper.

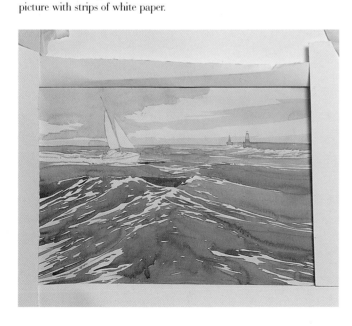

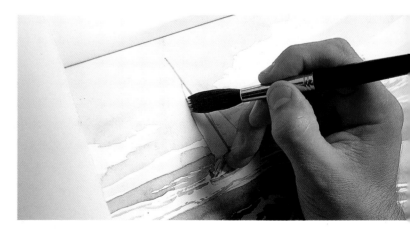

7 Special techniques (above)
To paint the tiny lines of shadow formed by the slight puckering of the sail fabric, the artist splays out the hairs of the pointed brush using a thumb and forefinger so that it produces a series of short parallel marks.

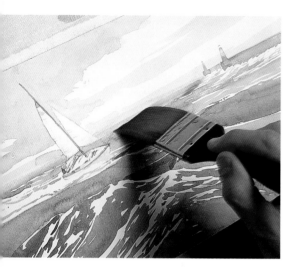

8 Softening edges (left)
To soften the line where water meets sky, he first goes over the area with the edge of a large nylon brush dipped in clean water.

9 Blotting off (below)
He then uses blotting paper to soak up the surplus color and moisture. It is essential to remove the water quickly, otherwise it may form backruns.

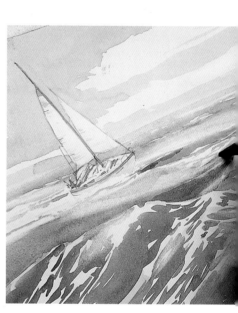

10 Linear detail (left)
The fine lines of the yacht and rigging are painted with a long-haired, very fine brush known as a rigger. This brush was designed specifically for marine artists, but it is also useful for painting grasses, or fine detail in flower studies.

11 Stressing the focal point (right)
To provide a touch of color contrast that draws attention to the focal point of the painting, yellow tints are laid over the waves immediately in front of the yacht.

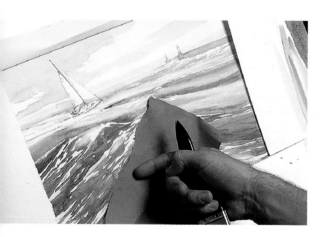
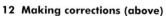

12 Making corrections (above)
The artist was dissatisfied with the front of the foreground wave, which seemed too heavy and interfered with the flow of the composition, so he has washed the area down with the large nylon brush and now blots it off preparatory to reworking.

13 Reworking (right)
The corrected area was left to dry before further washes were worked over it. Compare this with step 6 and you can see that this treatment works much better, with the crest of the wave crisper and better defined.

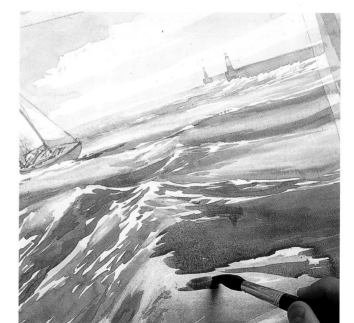

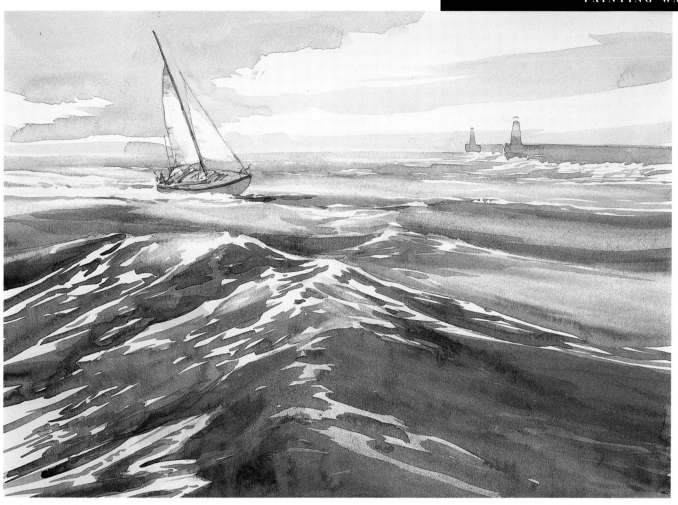

The finished painting's
attraction stems largely from the skillfull brushwork, but its success also owes much to the artist's willingness to make changes as he worked and to consider the painting as something more than just a depiction of a subject.

Reducing detail
As in the Cotman painting, the artist has wisely avoided over-definition of the clouds to prevent the sky claiming too much importance. Instead he has treated the sky as light and dark shapes, with the darker band sweeping in from right to center continuing the rhythmic movement of the sea.

Perspective

The painting gives a strong impression of space, created both by the use of paler colors toward the horizon and by the diminishing size of the waves and the brushmarks used to describe them.

Final touches

A painting can be spoiled by overworking and adding unnecessary details, but some final touches are important, as is the red stripe on the boat here, which provides a color accent that makes it stand out strongly against the surrounding gray-blues.

Varied brushwork
The variety of the brushwork here is exciting in itself, as well as being highly descriptive. Only one brush has been used, but the artist has manipulated it in such a way that it has produced many different marks.

Soft and hard edges

The foreground wave and the boat are given prominence by the contrast of edge qualities. The areas of water in front ofand behind the boat are soft-edged, while the wave has crisp, clear divisions between the negative and positive shapes.

Stonehenge,
John Constable, 1836–7

This painting provides the perfect example of how to create drama on a small scale—it is only slightly larger than the reproduction shown here, yet its impact is such that we can imagine it occupying a whole wall in a picture gallery. Constable learned much from studying the old masters, and in all of his compositions he exploited the chiaroscuro (bright against dark) effects beloved of painters such as Caravaggio and Rembrandt. It is mainly this, combined with the energetic and inventive brushwork, that makes the painting so exciting; but he has also used another kind of contrast, that between the solid forms of the stones and the evanescent quality of the sky. The stones and foreground are built up very strongly, serving as an anchor for the restless movement above.

The painting dates from the last years of Constable's life, and it is not known for certain whether it was done on the spot; it may have been partly worked in the studio from a smaller sketch. Constable sketched extensively out

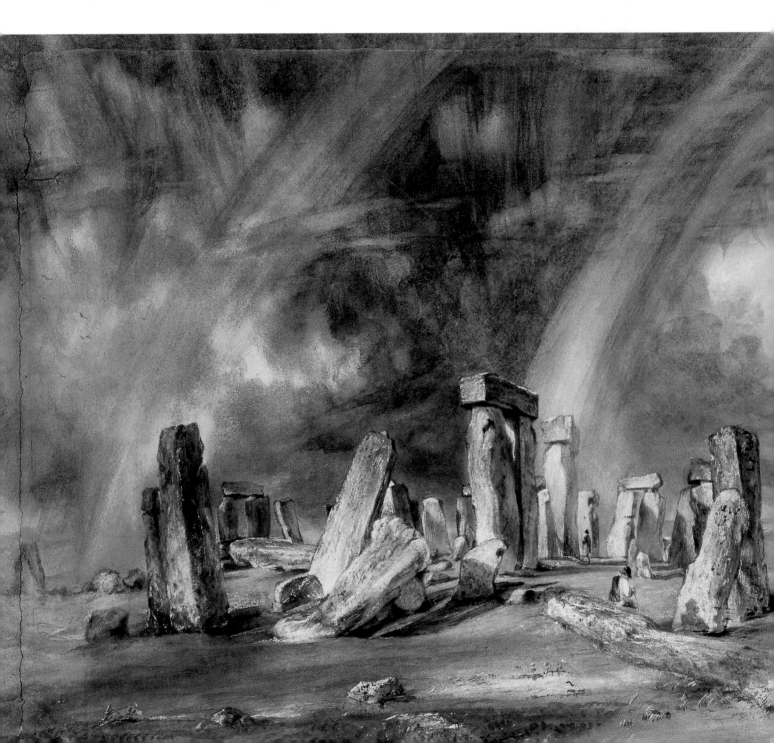

of doors and in his attempts to render the English landscape truthfully, he often abandoned traditional methods, as in the rapid brushwork of the sky here, and his works were criticized by his contemporaries for their lack of smooth finish. But he had his admirers, among them the Swiss-born painter Henry Fuseli, who is reported as saying, "I like the landscapes of Constable …but he makes me call for my greatcoat and umbrella." Looking at this painting, we can share the feeling.

Stonehenge,
by John Constable (1836–7),
Watercolor
Victoria and Albert Museum, London

ABOUT THE ARTIST

John Constable (1776–1837) was the son of a prosperous mill-owner in Suffolk, and began to paint the landscape around his home while still a boy, though he had reached his early twenties before he decided to make a career as an artist. He was unusual for his times in that he never left his native country. His contemporaries traveled widely in search of dramatic landscapes, but Constable found his subjects close to home, and wanted no others.

He was never fully accepted by the art establishment, and was only elected as a full member of the Royal Academy in the decade before his death, but is now recognized as one of the greats of landscape painting. He brought a new realism to the genre, turning away from the earlier conventions of highly idealized landscape. These artists, he said, "were always running after pictures and seeking the truth at secondhand," while his concern was to convey firsthand experience of weather, the effects of changing light, and the infinite variety of nature. "No two days are alike, nor even two hours; neither were there ever two leaves of a tree alike since the creation of the world." He was especially fascinated by skies, and made countless sketches of cloud formations, which he later used for reference in his studio. Today Constable's oil and watercolor sketches, which look forward to the Impressionist movement over a century later, are more admired than his large exhibition works.

EQUIVALENT COLORS

If you were to try to recreate the colors of the original painting in watercolor, the following colors would be useful as a basic palette:

 Indigo: sky

 Cobalt Blue: sky

 Vandyke Brown: sky, stones and foreground

 Permanent Rose: sky

 Raw Sienna: stones and foreground

 Prussian Blue: foreground and shadows

POINTS TO WATCH

Stormy skies and dramatic light effects make such an exciting subject that there is a danger of losing sight of the overall construction of the picture, especially if you are working on the spot and in a rush to capture the effects before they change. Constable, ever-mindful of composition, has planned his landscape with care, dividing the picture space in the classic way, with foreground leading into middle ground and thence to distance.

The focal point
As is most often the case in landscapes, the focal point is placed in the middle ground. Constable has emphasized this strong shape by giving it more solidity than the similarly shaped stones behind, and by contrasting it with the fluid curves of the double rainbow.

Echo and contrast
The downward brushstrokes used in this area perfectly describe the squall of rain, but they also play a compositional role in echoing the verticals of the stones beneath, and contrasting with the curves of the rainbow.

Color decisions
It would be tempting to make more of the rainbow by using the colors of the spectrum, but Constable has played it down in order to retain the overall, muted color scheme. In the context of the painting, the shapes made by the twin curves are more important than the colors.

Emphasizing scale
The central figure, dwarfed by the huge stones, plays a dual role. It creates additional interest in the central area, and also provides a sense of scale. We know the size of a person, as we do that of any familiar object, and can thus judge the landscape features against it.

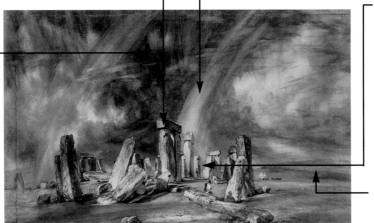

The distance
Most of the third plane of the picture space, the distance, is hidden by the stones, so this small area of sunlit hill is important in creating space and recession. It also provides a quiet resting place for the eye in the midst of the central drama.

Foreground interest
These stones provide a touch of foreground interest and make a link with the main stones of the henge in color and texture. An artist of today might treat this area in more generalized terms, but the rules of composition are less rigid now than they were in the 19th century.

Leading in
Although the picture is clearly divided into three separate "planes," they are linked so that they flow into one another. The diagonal formed by the fallen stone acts almost as a signpost, leading the eye in from the foreground to the focal point in the middle ground.

FOCUS ON TECHNIQUE

By Constable's time, watercolor had begun to be treated seriously as a medium, but had not yet acquired either the full body of techniques that we can list today, or the prejudices and lists of "dos and don'ts" that sprang up in the early 20th century. Artists felt free to experiment, finding their own way of working instead of following a prescribed set of rules, and Constable worked very much as he would in an oil painting, exploiting brushwork rather than laying flat washes, and using stiff brushes for the sky, instead of the usual

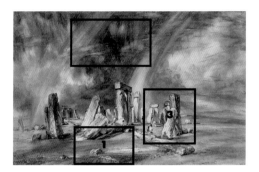

watercolor brushes. Although Constable produced some very fine watercolors, he did not use the medium regularly, and we cannot be sure of his precise techniques. However, many of the effects in this painting could be replicated with the help of modern "painting aids," as suggested below.

Directional brushwork (below)
This detail shows the way in which Constable has adapted his oil-painting methods to the very different medium of watercolor. He has used a stiff brush, following the direction of the sky's movement, and layering colors over one another wet on dry so that the brushmarks remain distinct. He may have thickened the paint with a medium such as gum arabic, which is useful for such effects. Paint can also be thickened with soap. Neither of these will affect the color or transparency of the paint, but they give it more body, so that it retains the marks of the brush and does not flow outward or into other colors.

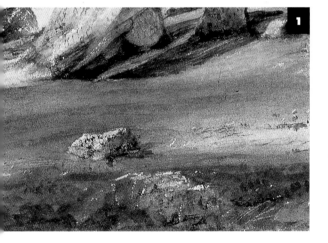

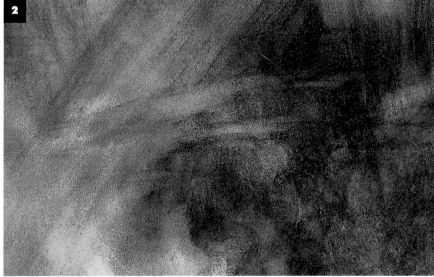

Small highlights (above)
These small flecks of creamy white, representing points of light, are typical of Constable's work. In his oil paintings, these were laid over other colors with thick, white paint, but here he has reserved the tiny highlights by using the texture of the paper, dragging rather dry paint over the surface so that it has only partially covered the grain. Some highlight areas were then reinforced by scratching away dry paint; you can see this especially clearly on the foreground grasses. An alternative method would be to paint on liquid frisket (masking fluid) and scuff it slightly with a finger before laying on the color.

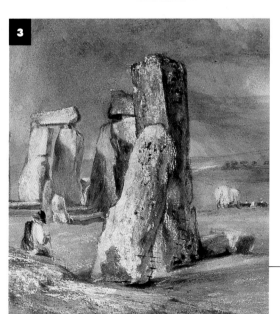

Creating texture (left)
The rough texture of the ancient stones is an important feature, and here the texture of the paper has helped to convey it. The paper has a rougher, less regular surface than today's popular Not surface, machine-made paper, so that the paint catches only on the top grain, producing a mottled effect. It is worth trying out a Rough paper for such effects, or they can be produced by the wax-resist method (see page 92), a popular technique in the modern watercolor painter's repertoire.

TUTORIAL: Drama in Landscape

As in the Constable painting shown on the previous pages, Kay Ohsten has used dramatic weather effects to give impact to the scene she has chosen, with the vibrant colors of the stormy sky making a backdrop for the sunlit buildings and warm colors of the roofs. She has deployed the medium with great skill, contrasting fluid, wet-in-wet effects and backruns in the sky with the more controlled treatment of the buildings. The texture of the buildings is an important element, stressing their solidity in contrast with the moving sky, and this has been suggested with touches of pastel.

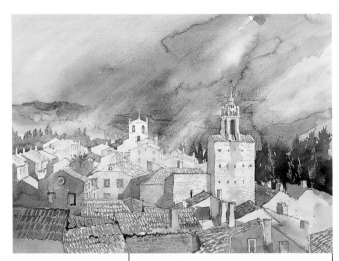

Rooftops in Provence,
by Kay Ohsten

COLORS USED

	Lemon yellow		Crimson
	Yellow ocher		Purple
	Cadmium orange		Cobalt blue
	Burnt umber		Vandyke brown
	Vermilion		Sap green

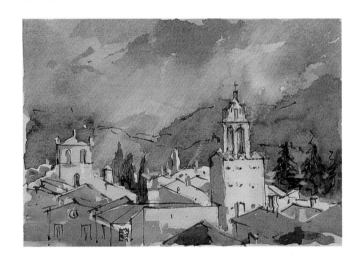

1 Working from a sketch (above)
This on-the-spot sketch provided the main reference for the painting, but the artist decided to make a number of changes, in particular bringing in more red roofs in the foreground in order to make a feature of these warm colors, which are then repeated in the sky.

TECHNIQUES USED

Backruns	page 78
Line and wash	page 84
Mixed media	page 86
Underdrawing	page 90
Wet in wet	page 92
Wet on dry	page 93

2 The underdrawing (right)
This is a complex subject, requiring a careful drawing before any color is laid on. The artist draws lightly with a very sharp pencil, checking each line and angle as she proceeds.

3 Establishing the colors (left)

The artist begins with the sunlit surfaces of the buildings, painting with very watery mixtures of lemon yellow, vermilion and purple, with the proportions slightly varied from area to area. Note how she uses the brush at an angle, following the line of the roof.

4 Special methods (below)

The pattern of the roof tiles is crucial to this foreground area, and the artist creates this by laying darker colors and then scraping into the wet paint with a rounded, pliable palette knife, an unusual but very effective method.

5 Defining edges (left)

It is essential to keep the edges of the buildings crisp and clear, especially where they will meet the dark sky, so a pen is used to outline the tops of the roofs. The ink is slightly watered so that the line is not too dark. A little pen drawing is also used to reinforce the tile pattern.

6 Counterchange (left)

Even before starting on the sky, the artist begins to build up a tonal pattern, mindful of the principle of counterchange—light against dark; dark against light—that forms a vital element in all paintings. Note how the line of the shadow is broken to suggest the texture of the rough masonry.

7 Judging tone and color (right)

The buildings are now sufficiently well-established for work to begin on the sky. Building up the foreground tones and colors first has provided the artist with a key against which she can gauge the strength of color needed. She works freely, wet in wet, but takes care not to allow the paint to slip over the edges of the buildings.

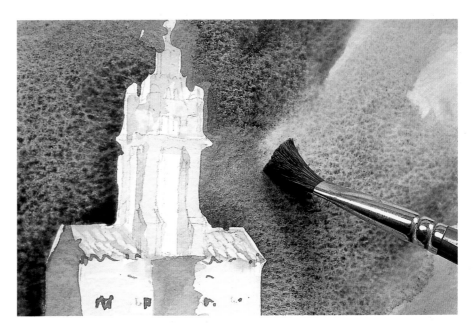

8 Controlling the paint (left)

Successful wet-in-wet effects require as much control as wet-on-dry methods, and the artists who work in this way make sure that they have paper towel or absorbent cotton to hand. A paper towel is now used to wipe out some of the paint, suggesting a lighter cloud. At the top, a light red-brown has been dropped into the darker blue-gray, creating a deliberate backrun.

9 Texture effects (right)

There are various special watercolor techniques that can help you create texture, but a quick and simple method is to bring in a dry medium such as pastel. A pastel stick is held on its side and dragged lightly over the paper so that it catches on the top of the grain, an effect that closely imitates the rough surface of the walls.

10 Drawing with a stick (right)

This line of shadow beneath the roof will help to give the building form and definition, so that it comes forward in space. The artist wants a broken, varied line that expresses the character of the old building, so rather than drawing with brush or pen, she uses a stick dipped into ink.

11 Muted colors (below)

Moving from the foreground to the distance, the artist builds up the shape of the hills. For this area she uses muted greens and purples, in contrast to the warm, strong colors of the foreground, and she avoids a uniform, hard edge by twisting the brush to vary the marks.

12 Lifting out (right)

The final stage is to create the shafts of sunlight falling onto the hills and central group of buildings, which will reinforce the feeling of space by drawing the eye in from the foreground to distance. Again the artist uses the lifting out method, but this time she dampens the paper towel first because the paint has dried.

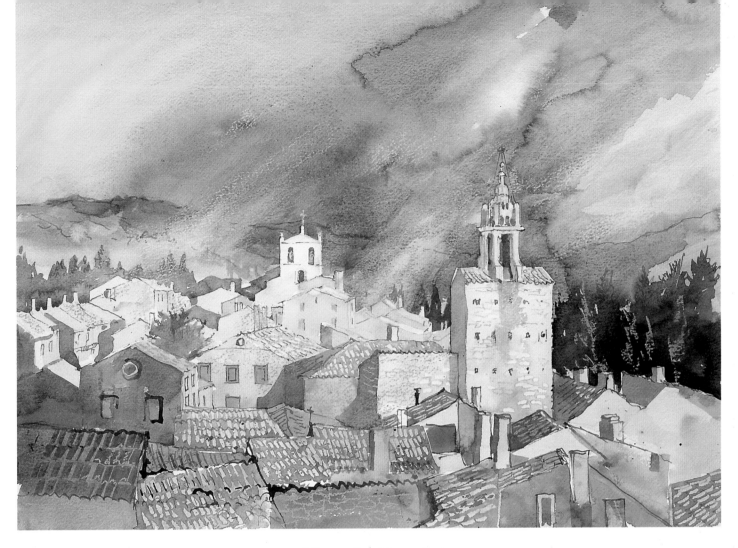

The finished painting is a lovely evocation of a specific place, as well as being full of drama and excitement. The composition has been cleverly planned so that the sloping roofs in the foreground lead the eye toward the central sunlit area; compare this to the sketch and you can see that the compostion here is much stronger.

Consistency of color
The overall color scheme is warm, with the key set by the red roofs, and to preserve the red/yellow theme, similar colors have also been used in the sky.

Edge qualities
Here you see another use of repeated colors, with the red roof color dropped into the sky. This has formed a backrun, resulting in a hard edge that echoes those on the building and makes a link between the two areas.

Consistency of technique
If pen or pastel drawing is restricted to just one area of the painting, it may look disjointed, so a little pastel has been laid over the paint here, making a link with the pastel work on the buildings. For the same reason, touches of pen drawing have been used on the hills.

Tonal balance
The balance of lights and darks can be seen all over the painting. This group of dark trees, which help to make the paler shape of the tower stand out, has a tonal echo on the other side of the painting, in the dark roof and shadowed buildings.

Playing down detail
The suggestion of pattern and texture in the foreground is important, but the artist has kept the pen and pastel drawing to a minimum so that it does not become over-obtrusive.

Granulation
The sky has been given extra interest by the use of two popular watercolor effects, backruns and granulation. In the latter, certain pigments separate out as they dry, creating an attractive grainy effect.

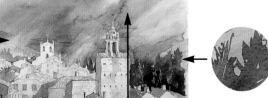

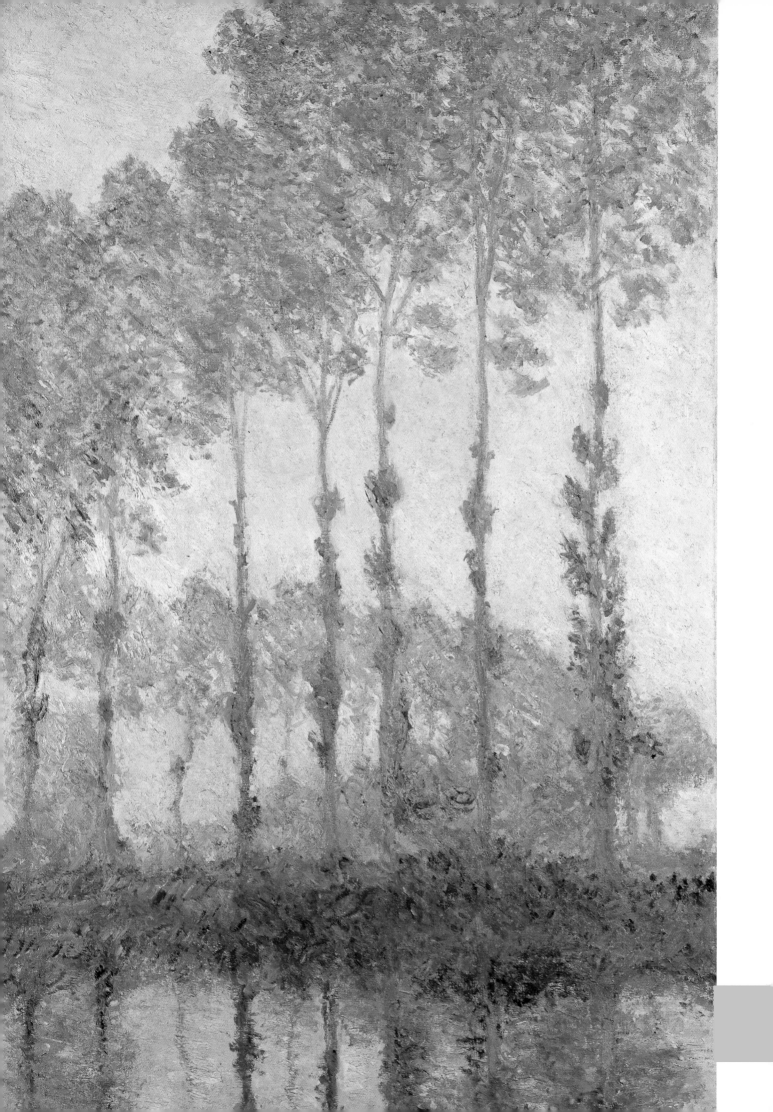

Poplars on the Banks of the Epte,
Claude Monet, 1891

This is one of Monet's series paintings, in which he recorded the same subject under different weather conditions and at different times of day. This gave him the opportunity to explore the effects of light that had become for him as important, or even more so, than the subjects themselves. As he said, "For me, a landscape does not exist in its own right since its appearance changes at every moment; but its surroundings bring it to life—the air and the light which vary continuously." The poplars series was painted over a period of several months—July until October—under difficult conditions. First, the trees were intended for felling that year so Monet had to persuade the owner of the land to leave them until he had finished, and second, the weather was unusually bad. His working method for this and other series paintings was to set up several canvases, work on one, and then move to the next as the light changed. He disciplined himself strictly, and would leave a painting "as soon as the sunlight left a certain leaf." In this painting there is no direct sunlight; it is believed to have been painted in the early evening, a time when the light is flatter than in the morning or afternoon, giving a narrower tonal range and gently glowing colors. Although Monet always painted direct from his subject, he sometimes reworked his landscapes in the studio, and this is one of the paintings to which he added finishing touches later to bring it to "exhibition standard;" in 1892 an entire exhibition was devoted to the poplars series.

ABOUT THE ARTIST

Claude Monet (1840–1926) is today seen as the central figure of the Impressionist movement, not only because he was a great artist, but also because he remained true to his artistic ideals throughout the whole of his long life. It was one of his paintings, *Impression, Sunrise*, exhibited in 1874, that gave the movement its name, though it was originally intended as a derisory comment on the "unfinished" look of the works on display.

Monet's youth was spent in Le Havre, where he met the French landscape painter Eugène Boudin and the Dutch painter J. B. Jongkind. Boudin introduced the young Monet to the practice of painting outdoors, which was less usual then than it is today, and Monet continued to work direct from the subject throughout his career.

From 1859 until about 1864 he studied in Paris, and met other artists, including Pissarro, Sisley, and Renoir, who were to form the nucleus of the new movement with Monet. Like many innovative artists, including several of his friends, Monet suffered considerable hardship in his early years, but he began to achieve recognition after meeting the cultured and influential picture dealer Durand-Ruel in London in 1870. By the turn of the century he was modestly affluent, able to purchase a house at Giverny and make his famous water garden, the subject of his wonderful later paintings, which today has become a place of pilgrimage.

EQUIVALENT COLORS

If you were to try to recreate the colors of the original painting in watercolor, the colors to the right would be useful as a basic palette:

Cerulean blue: sky, trees, trunks and shadows

Permanent rose: sky

Viridian: trees

Sap green: trees

Cadmium yellow: trees

Cadmium red: trees

Raw sienna: trees

Winsor violet: trees

Alizarin crimson: trunks and shadows

Poplars on the Banks of the Epte, by Claude Monet (1891), oil on canvas.

Varying the greens

Although this area reads as light green, there are several different shades of green, as well as dashes of light red and mid-blue. The small, deftly placed brushstrokes of these varied colors give a lovely impression of flickering movement. Similar effects can be achieved in watercolor, by building up the mass of foliage with small brushmarks rather than broad washes.

POINTS TO WATCH

Trees are not the easiest of subjects to paint; they require both careful observation and skill in handling the painting medium. A common mistake is to paint the trunks and branches in a uniform dark brown, and the foliage as an overall green, failing to take the effects of light into account. Another, stemming from inadequate observation, is to misunderstand the relationship of the trunk and branches—the skeleton of the tree—to the canopy of foliage. There are many different tree shapes, from tall, slender, uprights like these poplars, to the wide, spreading oak and chestnut trees, where the width is greater than the height. Spend some time analysing your subject, and then try to find ways of expressing their qualities by the way you use your brushes and colors.

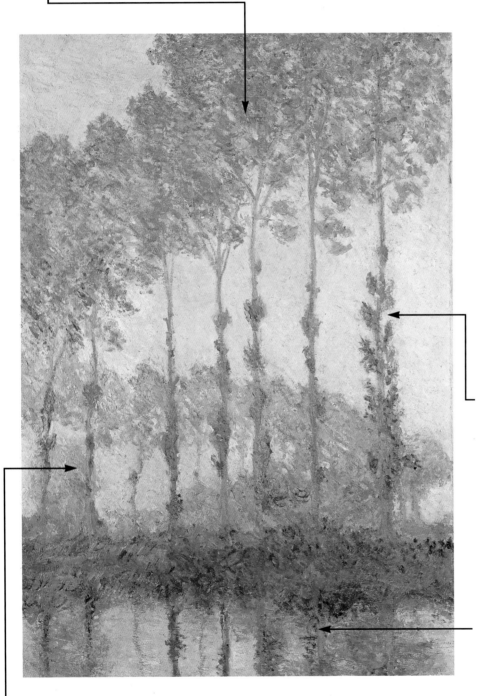

Tone and color

Several different colors have also been used for the tree trunks, with more blue-gray at the bottom, where they rise up from the brilliant blue of the riverbank, and more red-brown toward the top, where they are outlined against the pale sky. The overall tone of the trunks is relatively pale, but they stand out against the more distant line of trees because of the rich dark green used for the small clumps of foliage.

Reflections

Trees or other subjects reflected in water are an enticing subject, but take care not to make them too exact a copy of the objects, or you may lose the impression of water. Here they are very slightly blurred, with horizontal brushstrokes of pale blue-gray and white suggesting the surface of the water.

Breaking the lines

When painting delicate, slender tree trunks like these, or small branches, avoid making the edges too hard and regular. Monet has blurred some of the edges and "found" others, letting his vertical brushstrokes describe the upright growth. In watercolor, it is often better to use two or three brushstrokes rather than one long one for a trunk or branch.

FOCUS ON COMPOSITION

The kind of composition you choose for a tree painting will obviously depend on the type of trees you are portraying. Heavy-foliaged trees in summer, with broad, spreading canopies, for example, might call for a composition based on curves, perhaps using a landscape (horizontal rectangle) format. For these straight, upright poplars a geometric framework, with verticals crossing horizontals, is a natural choice. Notice how Monet has stressed the vertical emphasis by choosing an unusually narrow, upright canvas shape, rather than the standard rectangle, and how he has relieved the stark geometry of verticals and horizontals with the dramatic, sweeping, zigzag shape made by the mass of foliage.

Abstract values

Reduced to its bare bones in this way, the composition appears as an abstract, rather than a depiction of a specific subject. All good paintings have what are known as "abstract values," and can be seen as a juxtaposition of shapes as well as a landscape, still life, and so on. To make sure that these values are working, look at your picture in a mirror, or upside down. It will no longer be so familiar, and you will be able to assess the composition more easily.

Negative space

This term describes the spaces between things, like the sky in this painting. These spaces are as much a part of the composition as the positive ones—the tree trunks and foliage—and it is important not to make them too uniform. Monet has varied the distances between the tree trunks, and has used the patch of sky at top left as a shape in its own right, to counterbalance the strong mass of the foliage at top right.

TUTORIAL: Painting Trees

Trees are among the most difficult subjects for the watercolor painter, because it is easy to lose the delicacy of foliage and branches through overworking or clumsy brushwork. In his painting "Path through the Woods," Alan Oliver creates a wonderfully fresh and light effect by combining spattered paint and soft, wet-in-wet blends with decisive, calligraphic brushwork. He is working on stretched, Not-surface paper, and uses a large, round sable brush together with a small household brush, a bristle brush, and a flat Chinese brush.

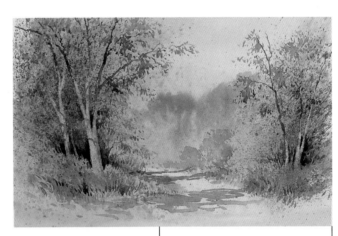

Path through the Woods,
by Alan Oliver

COLORS USED

 Cobalt blue

 Ultramarine

 Viridian

 Winsor lemon

 Indian yellow

 Permanent rose

 Winsor violet

1 Laying a variegated wash (above)
The artist has made no underdrawing, but is working from a sketch. His first step is to dampen the paper all over and lay a succession of light colors that blend into one another wet in wet, using a flat Chinese brush.

TECHNIQUES USED

Brushwork	page 80
Lifting out	page 83
Spattering	page 88
Washes	page 90
Wet in Wet	page 92
Wet on dry	page 93

2 Spattering (above)

With the paper still damp, the artist spatters further colors onto the surface, dipping the household brush into each color separately, and running his finger along it to release the paint. The spattered color will act as a base for the subsequent brushwork in the foliage areas.

3 Controlling the paint flow (above)

The paper is still damp but not wet, so the cobalt blue now laid on for the background trees does not flood into the sky. In addition, the board is held at a slight angle, so that the paint runs down rather than up; changing the angle of the board is the primary means of controlling the paint flow when working wet in wet.

4 Wiping out (right)

Referring to his sketch for the placing of the path, the artist carefully wipes out some of the spattered paint with tissue paper. An alternative method would have been to have protected the highlight areas with liquid frisket (masking fluid), but this would have created hard edges, which he did not want.

6 Combining different methods (above)

The rest of the painting is to be worked wet on dry. The paper has been left to dry before spattering further colors onto the central area of foliage, and the pointed sable brush is now used to begin the definition of the foreground grasses.

5 Varying the foliage colors (above)

The spattered paint and wet-in-wet washes have provided a form of color underpainting on which to build the details of the branches and foliage. Notice that, rather than restricting himself to green mixtures for the spatter work, the artist has used pure, unmixed colors: permanent rose, Winsor lemon, cobalt blue, and viridian.

7 Lifting out dry paint (left)

The pale shapes of the tree trunks are lifted out with a stiff bristle brush. More pressure is required to lift out dry paint, and it is not always possible to remove it completely, but in this case the method has proved ideal for the soft effect required.

8 Negative space (left)
The tree trunks are defined by the dark area of "negative space" around them, and here, a deep, rich, purplish red is taken carefully around the edges. The trunks immediately begin to look paler by contrast, although they are far from being pure white.

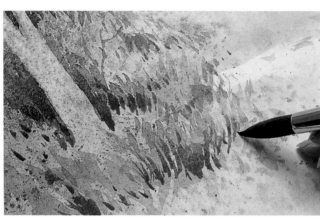

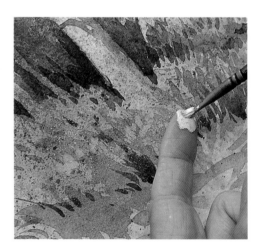

9 Brushwork (above)
As can be seen from this area of the painting, a large, pointed sable brush is a highly versatile implement, capable of a wide variety of brushmarks and a considerable degree of linear detail. Notice how both the shape and direction of the strokes are varied to suggest the movement of the leaves.

10 Building up color effects (above)
Each area of the painting is enlivened by the interplay of colors, as well as by the calligraphic quality of the brushwork. Beside and above the deep green now being added, you can see delicate pinks and mauves. The artist takes care not to obscure these by painting over them; instead, he builds up a network of different-colored brushmarks.

11 Shadow colors (left)
The shadows across the path play an important part in the composition, making a bridge between the two groups of trees. They must also link with the darker areas of foliage in terms of color, so a similar mixture, of cobalt blue and Winsor violet, is chosen, with the shadow color taken over onto the grassy banks on either side.

12 Spattering opaque paint (above)
The bluebells could have been reserved as white highlights and then painted in, but this would have interfered with the freedom of the brushwork in this area. Instead, they are painted over the earlier colors by spattering with an opaque mixture of gouache white and watercolor ultramarine. This gives a soft effect and does not over emphasize the flowers.

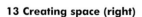

13 Creating space (right)
The path and the main trees are now complete, but the small green bush in the middle ground requires more emphasis to push the distant trees further back in space. This light green is both warmer in color and darker in tone than the background trees, and stands out well against them.

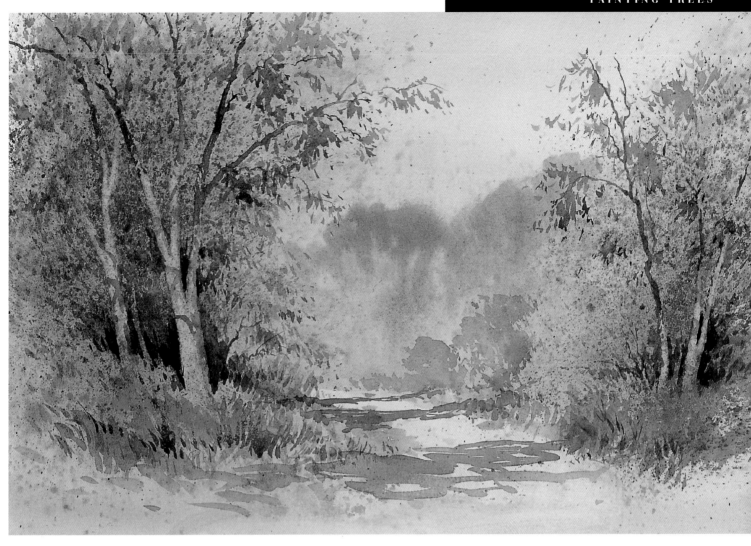

The finished picture has the fresh, sparkling quality that characterizes good watercolors. The trees are beautifully observed, and the foliage colors are interestingly varied.

Light and shadow
The way the tree trunks and branches are varied in tone, from light to mid-tone, with small touches of cast shadow, gives a strong feeling of light and suggests the presence of other trees, in front of these but outside the picture area.

Foliage colors
Although we read the trees and bushes as green, there are more pinks and red-browns than greens in this area, with the multicolored spatter overlaid in places with brushmarks of green.

Avoiding obtrusive effects
Inexperienced painters sometimes overuse "special" techniques, such as spattering, but here the technique has been subjugated to the overall effect so that it is less noticeable than the brushwork.

Compositional touches
Often, an artist will add something towards the end of the painting simply because the composition needs it. Thissmall bush, just such an important late addition, helps to draw the eye into the picture. It also defines the spatial planes, creating a natural boundary between the middle ground and the distance.

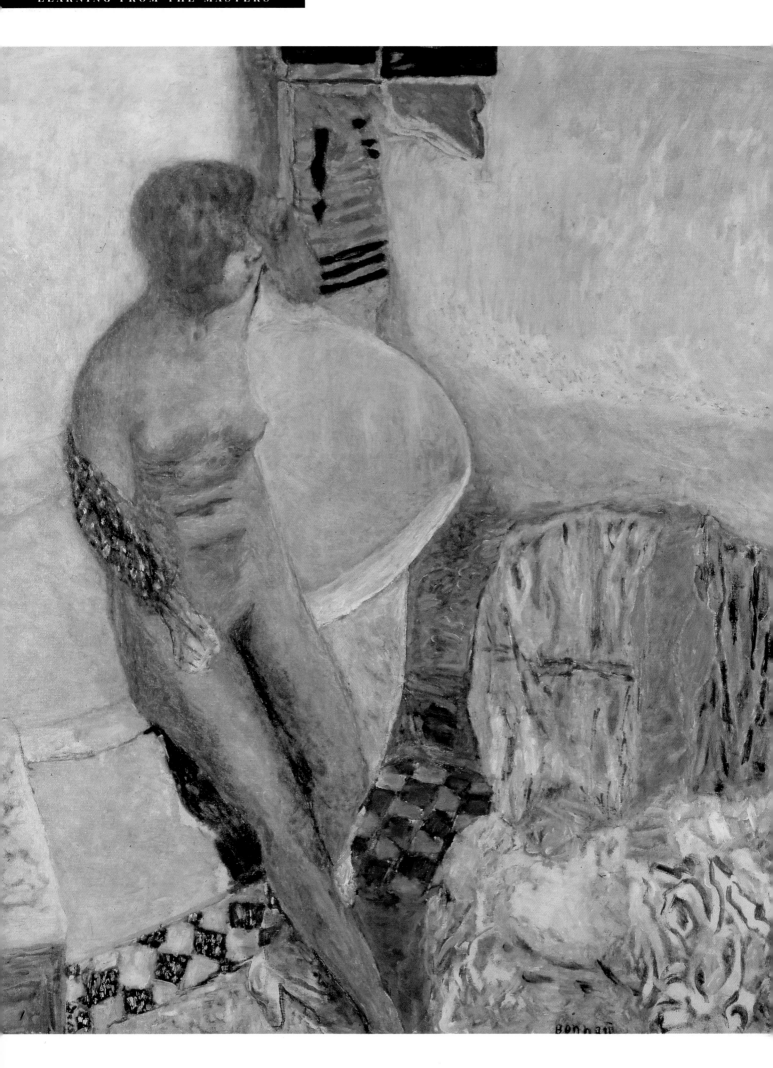

After the Bath, Pierre Bonnard, 1923

This is one of several hundred paintings of Bonnard's wife in the bathroom or bedroom, made throughout the years of their marriage—he was still painting her when she was in her seventies. Like all his domestic interiors, the painting is filled with light and color, and the apparent spontaneity, together with the casual clutter of the bathroom, might lead us to think that it was painted directly from the subject. But interestingly, although Bonnard's subjects were always rooted in the real world, he never painted on the spot. For a work such as this, he made drawings, but seldom any color notes; the paintings themselves were the result of his own experience and intuition. By painting away from the subject, he had a free hand with color and composition, and would often make changes to a painting, sometimes working on it over a period of years. On occasion, he also altered the format, by cutting off or adding a strip of canvas; he did not stretch his canvas, but worked on large pieces tacked to the wall. Picasso, who despised Bonnard's work, described it as "a potpourri of indecision," but to us the magic of his paintings fully justify his unusual artistic practices.

ABOUT THE ARTIST

Pierre Bonnard (1867–1947) came from a well-to-do middle-class family, and briefly considered a career in law before deciding to become a painter and settling in Paris. Here he met several fellow painters, and became a member of the Nabi group, whose work included stained glass and graphics. Bonnard himself concentrated more on lithography than on painting in the early years of his career, producing some much-praised book illustrations. His later landscapes and domestic interiors, with their glowing colors and emphasis on the qualities of light, are directly in the Impressionist tradition, but oddly he and his friends of the time seemed unaware of the Impressionist movement, and this vital influence does not appear in his work until around 1910. Once he had perfected his own distinctive style he rapidly became successful; indeed, toward the end of his life his paintings were fetching prices that horrified him—"all those zeros get on my nerves."

EQUIVALENT COLORS

If you were to try to recreate the colors of the original painting in watercolor, the following colors would be useful as a basic palette:

 Cerulean blue: bath and background

 Yellow ocher: bath, chair, background and fabric

 Alizarin crimson: bath, background, and chair

 Cadmium red: figure and fabric

 Ivory black: chair, figure and fabric

 Olive green: figure and fabric

 Permanent rose: figure

 Cobalt blue: chair

After the Bath,
by Pierre Bonnard (1923),
oil on canvas,
State Gallery of Modern Art, Munich.

FOCUS ON COLOR

What is most noticeable about all Bonnard's paintings is the lusciousness of the color and the feeling of light, achieved by working in a "high key," with no very dark tones. The colors in this painting are not vivid; there are none of the undiluted reds and blues that painters such as Matisse used, and no strong contrasts. The gentle glow of the painting stems from the use of close color harmonies in a middle-to-light tonal key, and delicate

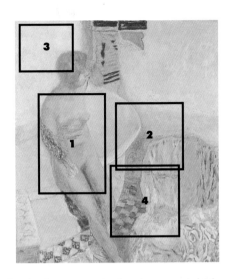

contrasts of warm and cool colors. The body, for example, is a warm pinkish gold, set off by the cool gray-blues of the bath and wall.

Another important lesson to learn from Bonnard's painting is the use of color echoes. By repeating the same or similar colors from one area to another, he creates an overall unity, with no jarring accents. Bonnard's color schemes could quite easily be adapted to watercolor work, but to emulate the passages of broken color (see opposite) you would need to make the paint opaque by adding white gouache.

COMPOSITION: POINTS TO WATCH

If your only experience of drawing and painting the nude has been in life classes, you may not have given much thought to composition, but when painting the nude in a setting it becomes paramount. The picture must hang together as a whole and be capable of being seen, not just as a portrayal of a person, but also as a series of shapes and colors that balance and contrast with one another. It is important not to isolate the figure, but to see it as one element in the painting. Try to create interest in each area, so that the viewer's eye travels into and around the painting, as Bonnard has done in his work.

Compositional rhythm
The curving shadow echoes the curves of the bath, following the opposite direction. The use of repeated curves gives a rhythm to the composition.

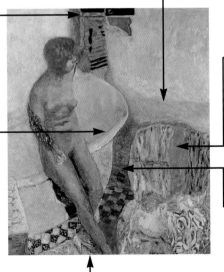

Blocking the eye
The solid, heavy shape made by the towels on the chair continues the rhythm of curves. It plays a further role in acting as a block so that the eye does not go out of the picture on the right, but is pushed in toward the focal point of the figure.

Balancing shapes
The thin, vertical shape made by the hanging towel balances the upright diagonal of the body. The tones and colors in both areas are similar.

Contrasting shapes
The strong curving shape of the bath contrasts with and accentuates the tall, thin, diagonal shape of the body.

Negative shapes
The "negative" shape—the space between the bath and the towel-draped chair—is as important as the positive shapes of the objects. The colors here echo those of the towel at the top.

"Breaking" the frame
Cropping the foot leads the eye up the horizontal of the leg and into the painting. It also helps to avoid isolating the figure, because it is not wholly contained within the frame.

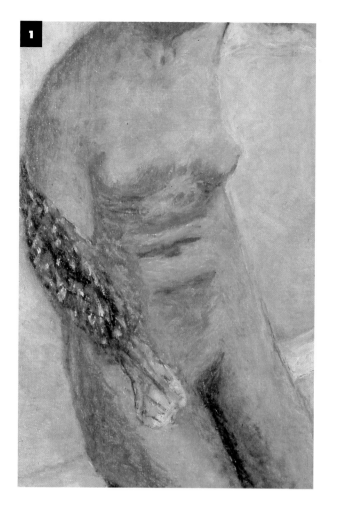

Color echoes (below)

The vivid blue among the pinks on the drapery is echoed by the shadow, a slightly muted version of the same color. The same blue is used in mixtures for the bath and on the wall behind the figure. Notice how the edge of the bath has been defined by taking a little of the rich, warm yellow-brown up around it.

Shadow colors (right)

The body is predominantly warm in color, but notice how cooler colors, gray-blues and gray-greens, have been used for the shadows, which are always cooler than the highlight areas. On the shoulder you can see a small patch of pinkish mauve that echoes the drapery on the far right of the painting.

Balancing tones and colors (below)

This and the hanging towels at the top of the picture are the darkest tones in the painting. They are linked by the use of similar colors, so that the deep, rich yellows and reds form a swathe through the center of the composition, running around the side of the bath to the top.

Broken color (above)

Bonnard applied his paint thinly, sometimes scraping down areas before laying further colors on top. Here he has used dabbing brushstrokes of the same gray-blue used for the bath, over a warmer yellowish gray.

TUTORIAL: The Nude in a Setting

Any painting of a figure in a bathroom brings Bonnard to mind, simply because he treated this theme so extensively and so superbly, but Glynis Barnes-Mellish brings her own very distinctive style to the subject in her painting "Nude in Bathroom." As in the Bonnard (see p.44), the main theme of the painting is beautifully conveyed light, but she uses a much more limited color scheme, modeling the forms primarily through tone, and treats the figure with a higher degree of detail. She works on Rough rag paper, because she finds it the surface best suited to her controlled blending techniques, and uses round sable brushes, plus a large, flat brush called a hake.

Nude in Bathroom,
by Glynis Barnes-Mellish

TECHNIQUES USED

Blending	page 79
Glazing	page 81
Underdrawing	page 90
Washes	page 90
Wet in wet	page 92
Wet on dry	page 93

COLORS USED

Alizarin crimson

Cadmium red

Light red

Red violet

Yellow ocher

Raw sienna,

Golden ocher

Burnt umber

Raw umber

French ultramarine

Cerulean blue

Cobalt blue

Winsor green

Sap green

Ivory black

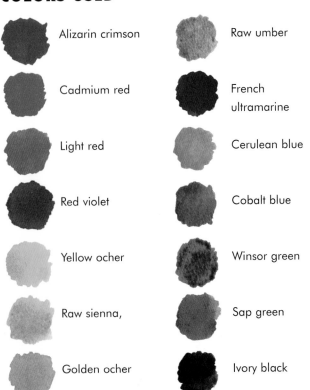

1 The basic skin color (above)

Rather than building up the skin colors in a series of separate colors, as an oil painter would do, the artist begins with an overall wash to establish the basic color. She uses a dilute mixture of alizarin crimson and yellow ocher, and leaves some areas, such as the highlights on the arms and breast, as white paper, softening the edges of the wash with a damp brush to avoid hard edges.

2 Tonal modeling (right)

The first wash is left to dry before the artist begins to build up the forms with a slightly darker version of the same color mixture, with a little cerulean blue added to produce a very slightly cooler color. Again, she softens the edges where one wash joins the other, to produce gentle tonal gradations.

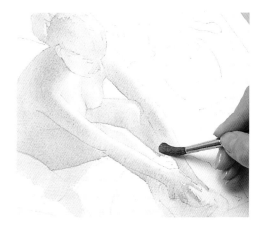

3 Using a large brush (below)

For the background and foreground that form a setting for the figure, the artist works loosely wet in wet with a flat 2-inch (5 cm) brush. The paint, a mixture of raw sienna and French ultramarine, is applied deliberately unevenly, with varying amounts of water, to suggest the effect of light filtered through steam.

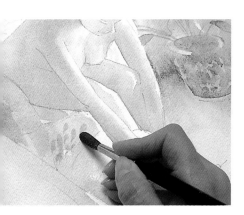

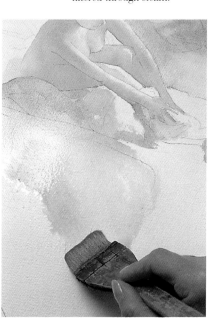

4 Light to dark (left)

The next step is to start bringing in the mid-tones. Further work has been done on the flower pot and area of background immediately behind the figure, and the same colors, based on the raw sienna and ultramarine mix, but with touches of crimson, yellow, and green, are introduced on the chair.

5 Keeping the colors consistent (above)

For each separate stage of the painting, the artist works over the whole of the picture surface, using similar color mixtures so that there is a relationship between each area. The hake brush is brought into play again, to lay the muted blue-gray mixture over the first application of weak yellow-pink.

7 Blending (above)

Now the artist turns her attention to the body again, continuing the modeling process with darker and slightly cooler colors, notably a touch of blue-gray on the arm. To blend the colors in this area she uses a soft, slightly damp brush, avoiding too much water because this could cause blotches and backruns.

6 Judging tones and colors (left)

Before working further on the figure, the artist needs to strengthen the tones and colors in this background area so that she can judge one against the other. To create a soft effect, she works colors into one another wet in wet, taking them carefully along the edge of the arm and around the pot; the wash is stopped when it meets dry paper.

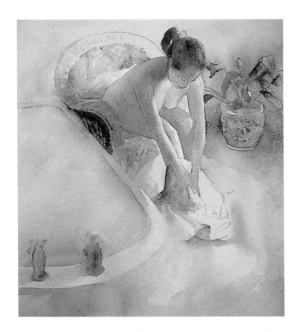

8 Order of working (left)

The painting strategy is based on a highly disciplined approach, with the picture built up in a series of separate stages from the lightest tones to the darkest. This is approximately the halfway stage, with all the elements of the composition established, but not fully defined.

9 Detail and texture (below)

A small, finely pointed brush is used to delineate the facial features. Notice how the rough grain of the paper has helped the artist to describe the texture of the hair; the darker color has been dragged over the lighter one, catching only on the top grain of the paper, to produce a broken-color effect.

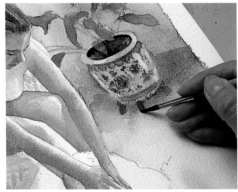

10 Building up the darks (above)

Now the artist can start to bring in the really dark tones that will give solidity to the figure and a strong tonal pattern to the composition. Except for the final detail on the face, the figure is now complete, and she returns to the potted plant, painting each of the legs of the pot with one firm stroke.

11 Continuing the process (right)

Moving across the picture, the artist works on the chair, accentuating the elegant curve of the arm and separating the chair from the bath by using dark tones on the side. She has already indicated the pattern of the basketwork, and now paints it more strongly, by using small, shaped brushmarks.

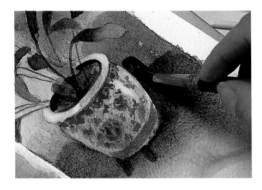

12 Making edges (above)

The artist never uses lines in her work; where crisp edges are required, these are produced by letting one wash meet another without blending. You can see this effect on the leaves, where dark green has been laid over light. The edge of the pot is defined by taking a deep, rich, purple-brown mixture around it.

13 Facial details (left)

The final touches are to increase the strength of tone in places on the body and to finalize the facial features. Even here, the artist avoids uniform, hard lines, using small dabs of paint for the mouth, and softening the bottoms of the eyebrows and lashes with a damp brush.

The finished picture shows not only a masterly control of the watercolor medium, but also great skill in organizing the composition and controlling the colors and tones.

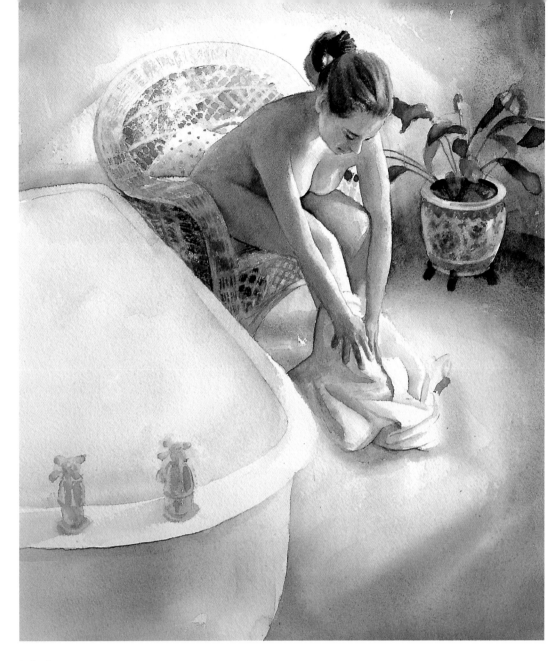

Compositional rhythm

The figure's posture is a vitally important element in the composition. Arrested in mid-movement, her bent head and downstretched arms continue the rhythm set up by the flowing curve of the bath.

Modeling form

Although the modeling is primarily tonal, cooler colors have been used for modeling form within the shadowed areas, with blues mixed into the basic skin tone.

Directing the eye

The taps have also been treated in a less detailed way than the figure and potted plant so that the eye travels over them and along the rim of the bath to the focal point.

Surface contrast

The background area around the potted plant has been worked wet in wet, and the loosely blended color provides an interesting contrast with the controlled blends used for the body.

Special effects

By working wet in wet with the large, flat brush, the artist has conveyed the impression of the gentle light, with the colors diffused through the steamy air. The softness of this foreground area also prevents it from claiming too much of the viewer's attention.

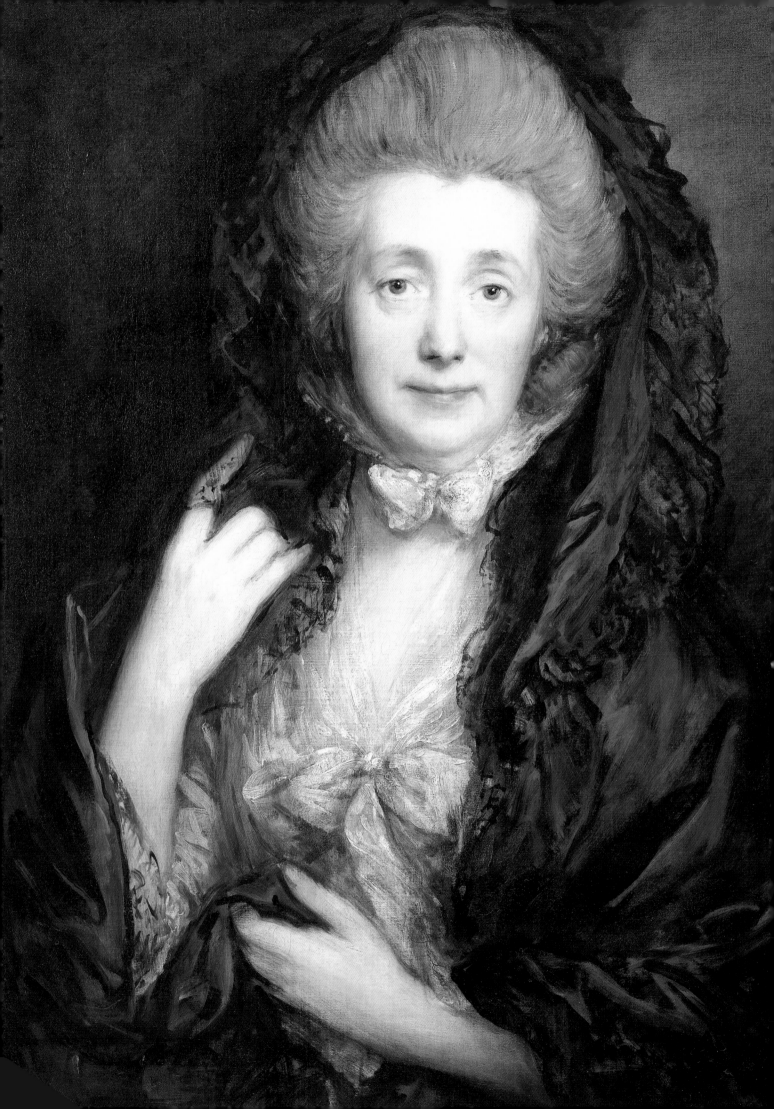

Portrait of the Artist's Wife,
Thomas Gainsborough, c. 1778

The two things that immediately strike us about this painting are the dramatic tonal contrasts and the wonderful luminosity of the skin. Gainsborough always gave careful consideration to tonal balance in his portraits, and his practice was to begin with his sitter posed in a poor light. This is rather like half-closing your eyes, cutting out color and detail, and making it easier to see the broad masses of light and dark. Having made a thin underpainting, mainly in tone, he would then rearrange the lighting and gradually build up the colors of skin and clothing, using layers of transparent and opaque glazes. He was particular about the pigments and mediums he used, and is thought to have favored an especially pure white pigment called Cremona white, and even to have mixed his pigments with ground glass on occasion. These oil-painting techniques are not, of course, possible to emulate in watercolor, but the demonstration on pp. 56 to 59 will give you some ideas about how to achieve similar effects.

ABOUT THE ARTIST

Thomas Gainsborough (1727–88) was born in Sudbury, Suffolk, and apprenticed to an engraver in London before setting up as a portrait painter in Ipswich in 1752. Here he painted local merchants and landowners, but later, when he moved first to Bath and then to London, his clientele expanded to encompass the aristocracy and high society of the day. His specialty was outdoor portraits, with his sitters often posed against a backdrop of trees in the grounds of their country houses. This allowed him to indulge his love of landscape painting; he once said that although portraiture was his profession, landscape was his pleasure.

FOCUS ON COMPOSITION

Although analysing the technique an oil painter uses does not help you paint better watercolors, you can learn a great deal about the wider concerns of the artist that are common to all paintings, whatever the medium. The most important of these is composition, and this painting provides an excellent example of a perfectly planned and balanced composition. Notice how the head and body are contained within the frame without looking in any way cramped, with the head just touching at the top, and the left wrist at the bottom. The hands play a threefold role. First, they introduce a light tone to balance that of the face; second, they break the symmetry of the centrally placed head; and third, they give the picture a distinct rhythm and sense of life.

Tonal balance
In this monochrome study you can see the tonal structure of the composition, with only three main tones: light, dark, and middle. Notice the strong pattern made by the white shapes against the dark.

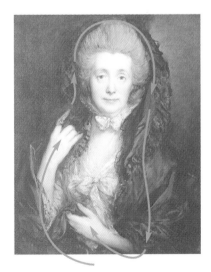

Compositional movement
The artist has organized the composition in such a way that our eye follows it around in a circular direction, from the hands up to the face, and thence down and around again. The left shoulder has been deliberately merged into the background, to avoid a hard line that might take attention from the face.

Portrait of the Artist's Wife,
by Thomas Gainsborough
(c. 1778),
oil on canvas,
Courtauld Institute Galleries, London.

POINTS TO WATCH

For a portrait to be successful, the head must appear solid and three-dimensional, and this involves understanding the structure and how the planes of the face fit together. For watercolor painters it also involves careful handling of the medium, because hard edges, where one wash meets another, can destroy form. You can see from this detail of the painting that all the edges are soft, with tones and colors flowing into one another, with almost imperceptible gradations.

The eye socket
It is important to see the eye, and upper and lower lids as a whole—a ball shape fitting into the socket of the skull. To avoid unevenly placed eyes, work on both at the same time. In watercolor painting, highlights must be reserved as white paper, or added last with white gouache paint.

Planes of the head
The forehead, a thin layer of flesh stretched over bone, is relatively flat in the middle, curving around sharply at the temple to give a pronounced shadow.

Soft gradations
The shadow on the side of the face, where the form turns away from the light, is also dark, but the gradations from dark to light are kept soft, in order to convey the round fleshiness of the cheek.

Definition
Small touches, like the dark shadows beneath the nostrils, help to define the form. Gainsborough has treated these boldly, because oil paintings are intended to be viewed from a distance; in watercolor you will need to be more precise.

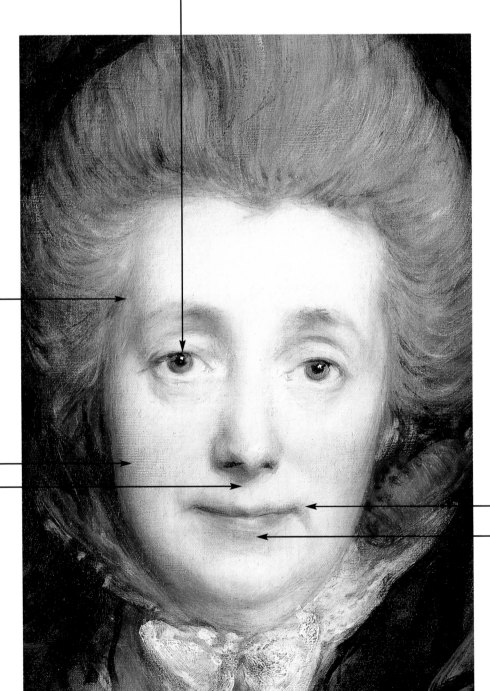

SKIN COLORS

In Gainsborough's time, colors were not bought in tubes; they were ground by hand from raw pigments and mixed with a variety of oils and varnishes. The choice of colors was more limited than it is today, and Gainsborough probably would have mixed all the skin colors from one or two yellows, a red, and a reddish brown, plus white. Modern watercolor painters have a wide choice of tube colors, but most skin colors can be mixed from a small palette of basic colors, the choice depending on the subject. The colors shown on the right are suggested watercolor equivalents for the colors used in Gainsborough's painting.

DARKER SKINS

For a ruddy-skinned person, the colors would be much the same but mixed in different proportions, but a black skin would usually call for less yellow and red, except in highlight areas. Black skins, of course, vary as much as "white" ones, but a good choice of basic colors would be those shown on the right.

PALE SKINS: SUGGESTED PALETTE

cadmium yellow

Payne's gray

yellow ocher

cobalt blue

alizarin crimson

burnt umber

cadmium red

DARK SKINS: SUGGESTED PALETTE

raw umber

ultramarine blue

alizarin crimson

viridian

yellow ocher

indigo

Winsor violet

The mouth
Lips are not a flat shape; they curve around the teeth, forming a small fold where this curve meets the bottom of the cheek and the muscle that controls the mouth.

Descriptive shadows
There will be a shadow beneath the lower lip, where the planes run inward and then out again at the chin.

TIPS FOR PORTRAIT PAINTERS

Posing is tiring, so let your model take regular breaks. Once you are satisfied with the pose, use a piece of chalk to mark the position of the feet and any part of the body touching a surface, such as an elbow on a chair. This will ensure that the sitter can resume the pose. If your portrait features elaborate clothing you might work from a photograph, but always paint the face and hands from life to capture subtle nuances of color and tone.

TUTORIAL: Painting Portraits

Watercolor is an ideal medium for achieving fine detail, and is traditionally used by botanical artists for this reason, but it is not usually associated with dark tones and powerful contrasts. However, in her painting "Cassandra," a portrait of her daughter, Glynis Barnes-Mellish demonstrates that her chosen medium can produce all that is required for a dramatic portrait—delicate skin tones, a fine degree of detail, and deep, rich tones and colors. She works on Rough-surfaced rag paper, that holds the paint well and facilitates blending methods, as well as allowing her to build up in layers without the colors muddying. Her brushes are a large and a small round sable, and a blending brush.

Cassandra,
by Glynis Barnes-Mellish

COLORS USED

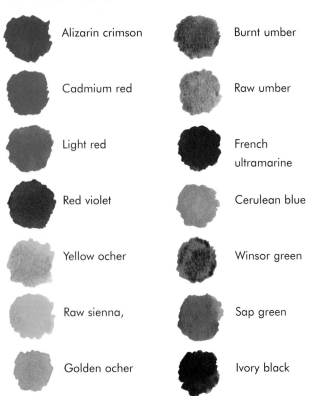

Alizarin crimson

Cadmium red

Light red

Red violet

Yellow ocher

Raw sienna,

Golden ocher

Burnt umber

Raw umber

French ultramarine

Cerulean blue

Winsor green

Sap green

Ivory black

1 Laying the base color (above)
After making a precise outline drawing in sharp pencil, a base wash, made from a mix of yellow ocher and alizarin crimson, is laid over the whole of the face and neck except for the eyes, where a little white is left.

TECHNIQUES USED

Blending	page 79
Brushwork	page 80
Glazing	page 81
Underdrawing	page 90
Washes	page 90
Wet in wet	page 92
Wet on dry	page 93

2 Modeling the forms (left)
Having left the first color to dry, the artist begins to model the hands, arms, and face with a darker version of the same mixture. To avoid hard edges, she softens the edges of each new wash with a soft brush dipped into clean water. The rough paper is also an aid to blending, because it holds the paint and prevents it from forming pools.

3 Working in separate areas (below)
The shape and form of the head are established, and the artist defines the features with a small, pointed brush. Her method is unusual, in that she brings the face to a fairly high stage of finish before working on the clothing and background, but she prefers to paint this key area first.

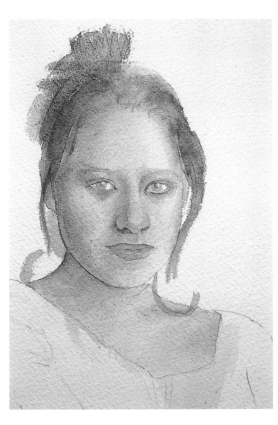

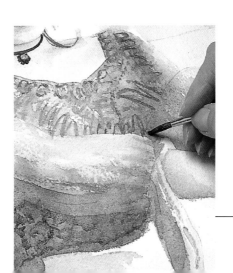

4 Skin colors (left)
The colors used for the skin are still based on the first crimson and yellow ocher, but with the addition of a little cerulean blue for the cool shadow on the side of the face. Some of this blue was also laid around the top and back of the head, cooling the red of the hair color laid on top of it, and thus giving form to the head.

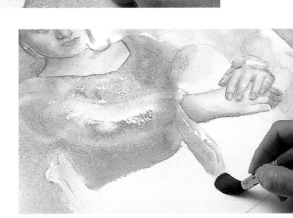

5 Introducing new colors (above)
The head and face are now sufficiently advanced for the artist to turn her attention to the clothing and background. Before returning to the face, she needs to have some of the other colors in place.

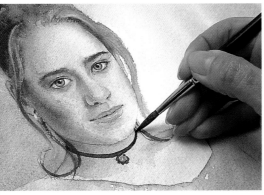

6 Comparing tones and colors (above)
The final depth of tone needed for the head could not easily be judged against white paper, but with the yellow-brown wash laid over the background and the clothing painted in a mid-tone, the artist is able to finalize the head and begin to introduce dark tones. She uses pure black, with very little water, for the choker and the pupils of the eyes.

7 Pattern and texture (left)
The pattern on the green top is painted with accurate strokes of a pointed brush, with careful attention paid to the perspective effects and the way that the fabric models the forms beneath. Notice how the texture has been suggested, most noticeably on the arm, by a series of small, "broken" washes and brushmarks, as well as by the rough surface of the paper.

8 Broad washes (left)

The skirt is smoother in texture, and here a dark wash is taken over the whole area, with slight tonal variations suggesting the forms. The artist uses a pointed, rather than a flat, brush, because she finds it better for manipulating the paint.

10 Deepening tones (above)

Now that the final stages have been reached, the tones are deepened all over the picture. A near-black is taken over the side of the leg, leaving some of the lighter color to suggest the slight highlight that models the shape. The hard edge was subsequently softened with a damp brush.

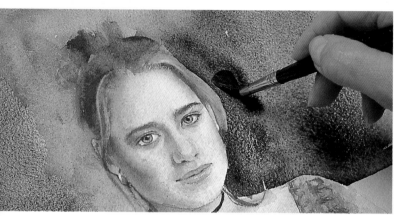

9 Overlaying colors (above)

In order to achieve unity of composition, it is important to bring some of the foreground color into the background, so the first stage is to lay a series of red-brown washes that echo the color of the hair and dark side of the face. The artist works loosely, wet in wet, to suggest an area of undefined space that brings the face into sharper focus.

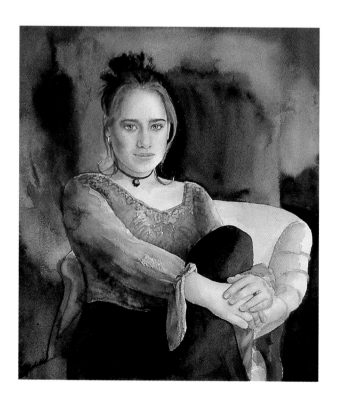

11 Background tones (left)

The skirt is the darkest tone in the painting, and needs to be completed before the artist decides on the final tones for the background. The run of paint seen earlier has now been painted over with a dark tone, that has been brought in again on the other side, throwing the light-struck side of the face into high relief.

12 Final detail (above)

The small touch of dark pattern here is important for several reasons. It makes a visual link with the black choker, marks the separation of the arm from the body, and helps to accentuate the forward thrust of the arm.

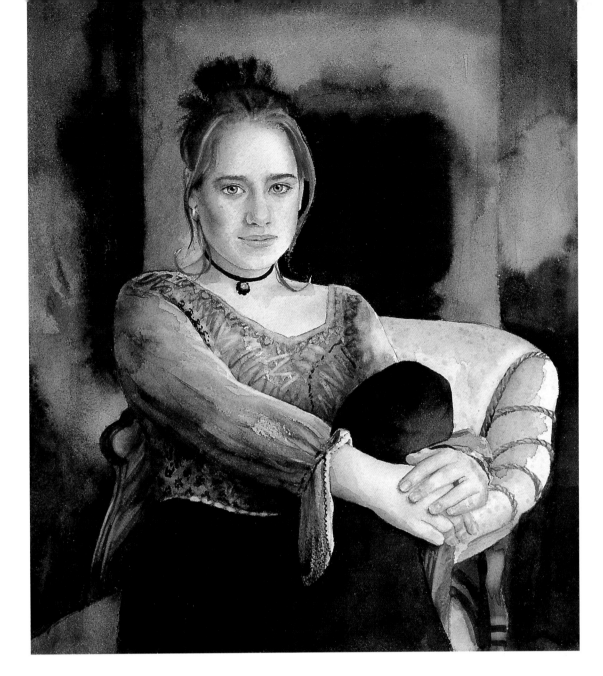

The finished picture. As in the Gainsborough portrait (see p. 52), the delicate colors of the skin glow out against the dark background, the face is expressive, the composition has a pleasing sense of rhythm, and the textures add a touch of luxury.

Surface contrasts
The loose and textured treatment of the background, where paint has been encouraged to form pools and backruns, contrasts with the controlled and precise technique used for the face and the body.

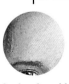

Hard and soft edges
The face is very subtly modeled, with gentle gradations of tone around the cheeks and forehead, and harder edges for the sharp changes in plane, such as on the top lip.

Hands in portraiture
The face is always the focal point in a portrait, and when hands are included there is a danger that they may become over-important and start vying for attention. Here, they form part of the curve that takes the eye upward to the face, starting with the sofa back and arm, then running through the hands and up the arm.

Dark against light
There is a strong tonal pattern running right through the painting, with darks played off against lights. The black skirt makes a shape that balances those in the background and accentuates the pale shape made by the face, neck, sofa, and hands.

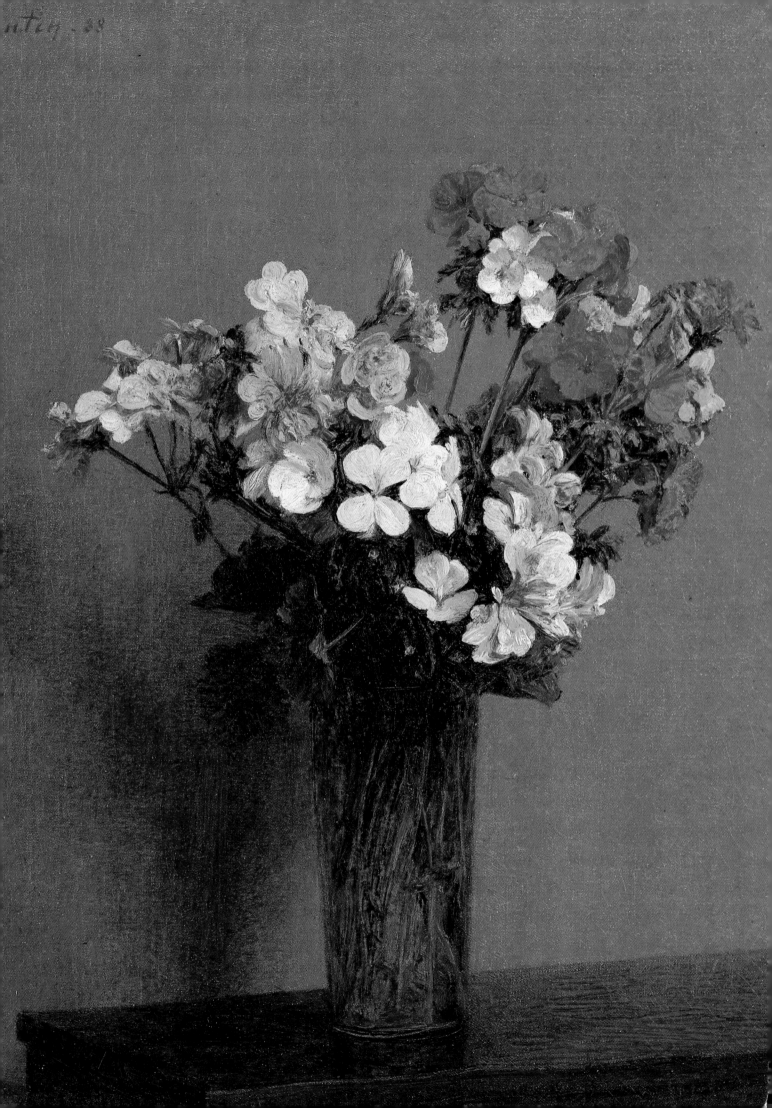

Geraniums,
Henri Fantin-Latour, 1888

The initial impact of this painting stems from both the apparent simplicity of the arrangement and the glowing colors that make the flowers appear almost as though illuminated from within. The greenish brown of the background plays an important part in the overall color scheme, acting as a foil for the red flowers and providing a middle tone to accentuate the high tones of the white and pale pink flowers. The artist has given the flowers a realistically three-dimensional quality by using thick, juicy paint for the petals, so that they stand out against the thinner, flatter paint of the background, and by making skillful use of shadows and highlights. In watercolor work, you cannot build up thick paint in this way, but you can arrange the lighting so that it models the forms, as it does here. The light comes from the right, casting a shadow on the background and creating darker tones on the petals that turn from the light. You can see this especially clearly on the bowl-shaped white flower on the left beneath the pink ones.

ABOUT THE ARTIST

The French artist Henri Fantin-Latour (1836–1904) studied under his father, a pastel painter, and later became friendly with several other prominent artists of the day, including Delacroix, Corot, Courbet, and Whistler—the latter introduced him to English artistic circles, and his work became popular in England. He is now best known for his flower paintings, but he also painted portrait groups, and in later life devoted much of his time to lithography. He and other French painters of the time brought a new naturalism to the treatment of flower painting, with a realistic appreciation of their colors, textures, and growing habits.

EQUIVALENT COLORS

If you were to try to recreate the colors of the original painting in watercolor, the following colors would be useful as a basic palette:

 Raw sienna: background

 Burnt umber: background, table and shadows

 Burnt sienna: table and shadows

 Viridian: foliage and flowers

 Cadmium yellow: foliage

 Cadmium red: flowers

 Permanent rose: flowers

 Vandyke brown: vase and dark areas

 Ivory black: vase and dark areas

FOCUS ON COMPOSITION

Because the painting appears so simple and natural, one does not immediately notice how carefully the composition has been structured. It is based on what artists call "the unseen triangle," a commonly used device of flower painters, with the tall cylinder of the vase balancing ▶

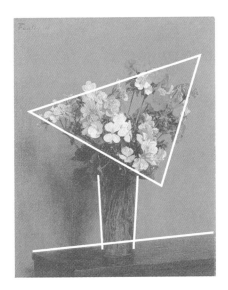

Triangular shapes
The mass of flowers form a rough triangle. When using this idea, avoid making the triangle too obvious, and have the apex off-center, as here. Notice how the diagonal line of the back of the table runs in the opposite direction to that formed by the bottom of the triangle, with the cylinder of the vase making a link between the two.

the shape made by the flowers and being anchored by the shallow diagonals of the table top. Although the vase is placed directly in the center, the symmetry is broken both by the roughly triangular shape and the end of the table top on the left.

OTHER COMPOSITIONS

This composition could work for a watercolor, but would need additional interest in the background. A flat background like this is difficult to achieve in watercolor, and could look dull, so you might consider varying the background colors, perhaps working wet in wet (see p. 92) or bringing in a suggestion of other elements, such as furniture or a window frame. Alternatively, you could cut down the background area by changing the composition, as suggested below.

Cropping the composition

You do not have to paint the whole of your flower arrangement. You can crop the vase and let some of the flowers go out of the frame at the top or sides. This can be effective, as it makes them appear freer and more natural, no longer anchored and constrained by the edges of the picture.

Balancing shapes

Alternatively, you could abandon the triangle device and rearrange the flowers to make the most of a tall, rectangular format, letting some go out of the frame at the top. You might also balance them by introducing a bunch of grapes or other fruit at bottom right.

Perspective effects

Observe the shapes of the flowers carefully, and the angle of viewing. This flower is slightly turned away, so that the stamen is not central. The flower has been worked in thick paint, wet in wet, but in watercolor you would reserve white paper for the lower petals and just make one or two broad brushstrokes of a darker color for the shadowed petals.

Flower character

Often you can generalize the leaves in a floral arrangement, simply treating them as a broad mass of tone and color, to offset the brighter or lighter color of the flowers. But the large round leaves of geraniums are a feature of this plant, and help to build up a complete picture of it.

Flower structure

When painting flowers in a clear container, take care that the stems look credible in relation to the angle of the upper stems and flower heads. You need not paint each one in detail, but make sure they follow through, as they do in here.

POINTS TO WATCH

One of the common causes of failure in flower painting, whatever the medium used, is overworking in an attempt to achieve precise detail, so that the colors become tired and muddy-looking, and the flowers lose all sense of life. A golden rule is never to use two brushstrokes where one will do, so try to work broadly, at least initially, and start with a careful pencil drawing to ensure the minimum of corrections. The oil painter can work over an incorrect area and make changes as he/she works, but this is only possible to a limited extent in watercolor.

Lost and found edges
The edges where the light petals meet the darker background, are vital in describing the shapes. Here the flowers have been worked over the background; in watercolor you can use liquid frisket (masking fluid) (see p. 85), paint the background first, and then complete the flowers. Don't, however, make all the edges uniformly hard. Notice that on the darker flowers on the right they merge into the background. These are known as "lost edges."

Dimensionality
The red flowers overlap the white ones, casting a shadow. Look for effects like this, because they help to give a three-dimensional quality to your painting.

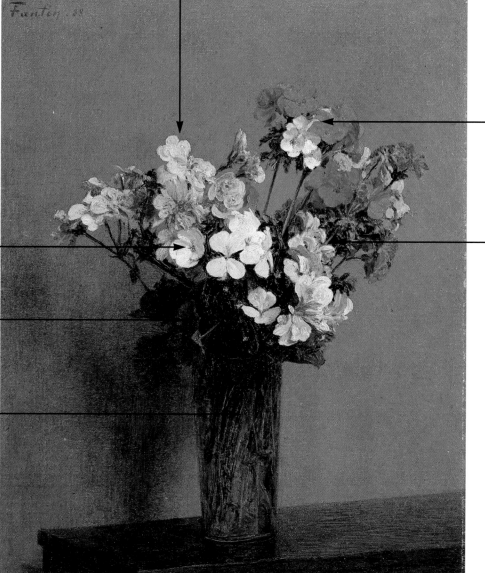

Varying the focus
In order to create a focal point, or center of interest, treat one group of the foreground flowers sharply, and let others behind them go slightly "out of focus." Here the white flowers stand out strongly because of the crisp edges and the tonal contrast with the dark leaves.

TUTORIAL: Painting Flowers

This painting clearly shows how both the working methods and the composition are affected by the medium chosen. In the oil painting shown on the previous pages, the flowers are set against a relatively dark background, and are pushed back in space so that the vase and table top play a part in the composition. This type of setting does not suit watercolor, so in her painting "A Summer Posy," Adalene Fletcher has brought the flowers forward to the front of the picture plane, cropping the vase so that the horizontal surface of the table is out of the picture, and restricting the background to two areas of deep tone, to the right and left of the flower group.

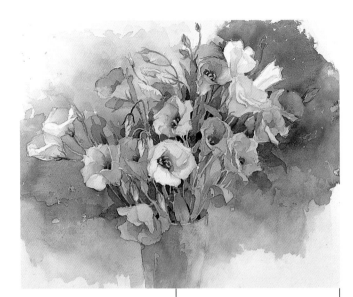

A Summer Posy,
by Adalene Fletcher

COLORS USED

Aureolin yellow

Quinacridone gold

Permanent rose

Quinacridone magenta

Quinacridone red

Winsor blue

Winsor violet

Prussian green

Rowney olive-green

Green gold

1 Underdrawing (above)
The artist is working on cold-pressed (Not-surface) Whatman paper, in a weight heavy enough not to need stretching. She starts by making a careful outline drawing in pencil, concentrating on the shapes of the flower heads and the angles at which they are seen.

TECHNIQUES USED

Glazing	page 81
Spatter	page 88
Underdrawing	page 90
Washes	page 90
Wet in wet	page 92
Wet on dry	page 93

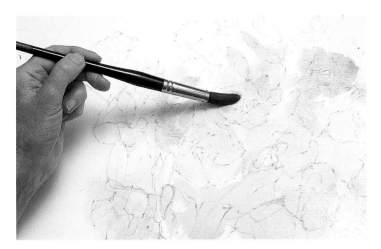

2 The high colors (left)

The first stage is to indicate the highest colors. The artist works wet in wet for these first washes, starting with yellow and then dropping in touches of rose pink with the tip of the brush. She has damped the paper only where she wants the colors to run into one another.

3 Working over an underpainting (right)

The rest of the picture, except for the background, will be worked wet on dry, with this ghost image providing a guide for the choice and placing of the subsequent colors. Notice how carefully the wet in wet has been controlled, with the paper allowed to dry out at top right so that a white highlight could be reserved for the flower.

4 Laying the second tone (above)

The artist uses the classic watercolor method, of building up from light tones to dark in a series of layers. She has left the wet-in-wet washes to dry, and starts to build the colors and shapes of the flowers, taking a deep pink around the pencilled outlines of the central stamens.

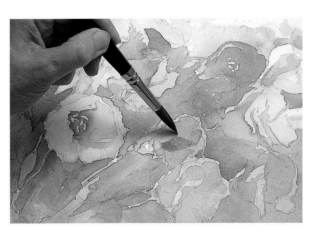

5 The importance of drawing (above)

Here again, you can see how vital it was to draw the pencil outlines accurately. The deep green defines the edges of the petals and leaves, and must be taken around them with care and precision.

6 Working consistently (above)

The artist works over all the painting at the same time, rather than bringing one area to completion before another. She continues to build up the depth of color in the flower heads, placing her washes so that they create crisp edges that define the shapes.

7 Bringing in the darks (left)

At this stage, with the main colors established, the artist can start to bring in more depth of tone. Again using a pointed sable brush, well loaded with paint, she takes dark green around the stems and bottom of the flower.

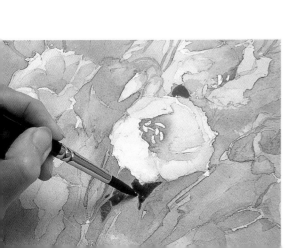

8 Varied effects (right)
The half-completed painting shows the combination of the two main watercolor methods, wet in wet and wet on dry. The latter gives sharp, crisp edges that make the flowers stand out against the softer, wet-in-wet work.

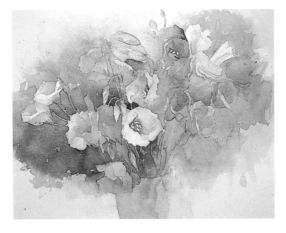

9 The background (below)
For the background, an amorphous area of dark tone that contrasts with the crisp edges and delicate colors of the flowers, the artist returns to the wet-in-wet method. She lays the board flat so that the colors flow into one another but do not run down the paper.

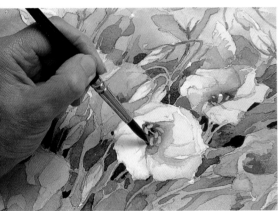

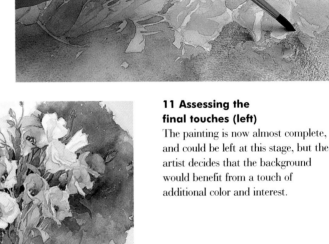

10 Building up form (above)
Further dark tones have been laid around the stems, creating a lively pattern of light and dark, and the artist now builds up the form of the middle flower, dropping small touches of very deep color into the center. The stamens, now originally reserved as white highlights, have now been darkened, as they are in shadow.

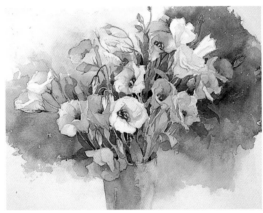

11 Assessing the final touches (left)
The painting is now almost complete, and could be left at this stage, but the artist decides that the background would benefit from a touch of additional color and interest.

12 Spattering (left)
Pinks appear among the wet-in-wet background colors to provide a link with the flowers, and this link is now strengthened by flicking droplets of deep mauve-red over the green in the left-hand area.

13 Balancing colors (above)
Yellow has already been introduced beneath the green on the right-hand area of the background, and this is now used again on the other side so that the two areas of background balance one another. Touches of this same yellow appear on the light-struck sides of the central flowers.

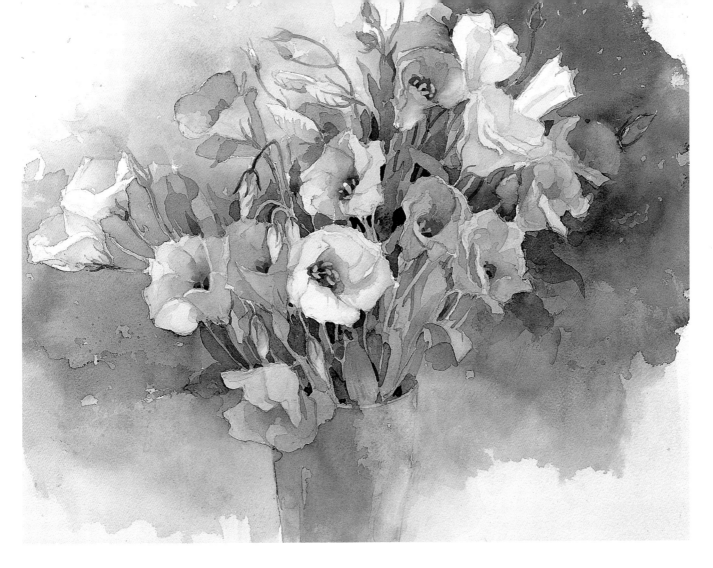

The finished picture has the lovely, fresh sparkle that characterizes the best watercolor flower paintings, but it also has considerable strength, with the flowers firmly modeled and the composition planned with care.

The overall shape
In addition to paying attention to each flower, the artist has not neglected the overall shape made by the group. As in the Fantin-Latour painting, this is based on a triangle, sloping upward to the top right.

Varying the focus
The central flower forms a focal point in the painting, and has been brought into sharp focus by being treated in more detail than the background flowers, as well as by using stronger tonal contrasts.

Overlapping
The way that these two flowers overlap each other helps the illusion of three-dimensionality, but care has been taken to overlap them only slightly so that the shape of the top flower can still be seen clearly.

The pattern element
The intricate, busy pattern made by the light and dark tones of the leaves and stems provides a lively setting for the flowers, and contrasts with their more rounded and solid forms.

Defining the shape
The vase plays an important role in the composition, providing a vertical that carries the eye upward to the flowers, but it was essential not to overemphasize it, so it has been treated very lightly, with its shape defined mainly through the ellipse just visible at the top.

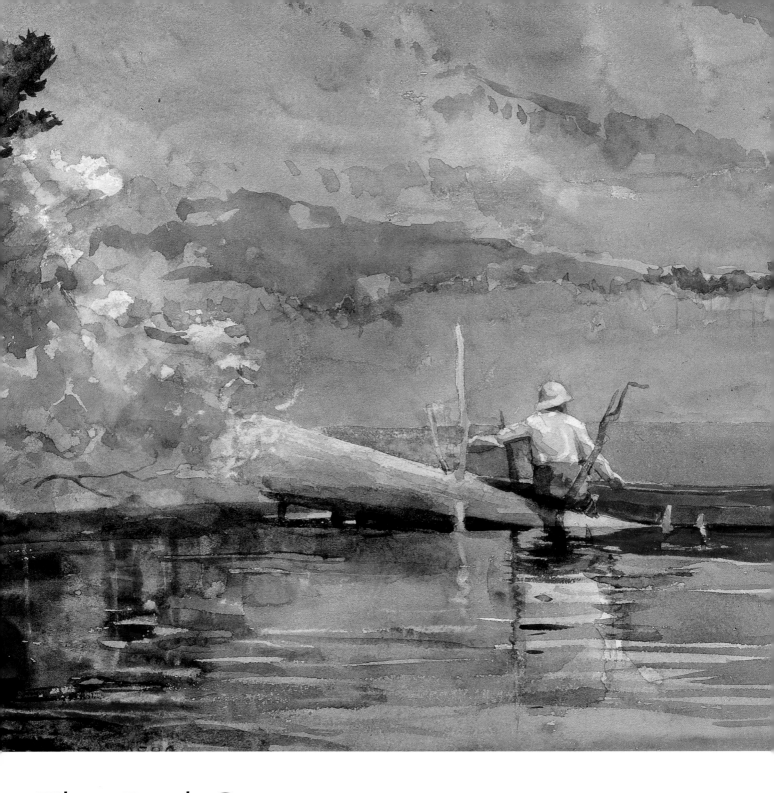

The Red Canoe, Winslow Homer, 1889

This painting is one of a series of masterly watercolors made in the Adirondack Mountains. Homer was led there by his passion for fishing, and the well-to-do hunting fraternity who were his companions on these expeditions were among his most enthusiastic patrons. By this time, Homer's watercolors were selling well, and the area itself was a popular one with the art-buying public, having been visited by several other artists. In all the Adirondack paintings, Homer's love of the landscape is clearly evident, as is his feeling for the watercolor medium, used with breathtaking skill and a freedom that was new in 19th-century watercolor painting. Most of the paintings feature figures, sometimes a solitary fisherman in a canoe, a huntsman in the woods, or a local guide or woodcutter. Always the figures are integrated into the landscape, so that they seem a natural part of it. Indeed, they allow the artist to give a more complete account than would an empty landscape: here the fisherman and his boat explain that this is a place where people do certain things and have a role related to the landscape.

The Red Canoe,
by Winslow Homer (1889),
watercolor on paper,
Private collection.

ABOUT THE ARTIST

Winslow Homer (1836–1910) turned to painting from illustration, and after working in oils for some time, made his name with a large oil painting called *Prisoners from the Front*, painted and exhibited in 1866. His watercolors are now more widely known than his oils, but he did not turn to the medium until 1873, when he had been a professional artist for some 20 years. This was mainly because there was a limited market for watercolors; the medium was viewed as one more suitable for amateurs than serious painters. This attitude was soon to change, however. In 1866 the American Water Color Society was formed and began to hold annual exhibitions. In 1873 they mounted a huge international exhibition, which finally put watercolor on the map. Homer was quick to respond to the new interest, and although his early watercolors were criticized as "unfinished" in contrast to the tight, detailed style of the day, he soon began to build up a clientele, and by the later decades of the century he had no want of buyers.

EQUIVALENT COLORS

If you were to try to recreate the colors of the original painting in watercolor, the following colors would be useful as a basic palette:

 Paynes gray: background and foliage

 Prussian blue: background and water

 Lemon yellow: foliage

 Light red: boat

POINTS TO WATCH

When painting a figure or group of figures in a landscape setting, it is important to remember that the human element can assume too much prominence in the composition, with the landscape taking second place or simply acting as a backdrop. This is because we identify more immediately with people than with rocks, trees, and other landscape features. One way to avoid this is to set any people in the middle distance, where they perform a useful pictorial role in drawing the eye in to the picture. In Homer's painting the figure is prominently placed, but there is sufficient interest in the immediate foreground, with the sharp tonal contrasts and strong colors in the reflections and ripples, to avoid it becoming over-dominant. Notice also how he has set up a series of pictorial links so that the figure and boat are not isolated in space. ▶

Balancing shapes
The verticals and horizontals of the figure, mooring the post, boat, and log, are balanced by this group of dark trees.

Tonal echoes
These pale shapes, echoing the light tones of the figure and reflection, are important to the composition, making another link between areas of the picture.

Color echoes
To make a pictorial link with the immediate foreground and middle distance, the rich red-brown of the boat is repeated in this area.

Balancing tones
The balance of light and dark tones is carefully planned. This touch of dark green echoes the tone of the boat and the dark line of mountains at top right.

Placing the lights
The log is the same tone and color as the fisherman's shirt and hat, the reflections, and the white cloud, setting up a series of tone echoes throughout the painting.

Playing down the figure
Although the figure is the focal point, and placed centrally, framed by the canoe and pale shape of the log, it is treated as broadly as the foreground water and the background hills, so that it takes its place as one of the elements in the landscape.

FOCUS ON TECHNIQUE

What distinguishes Homer's watercolors from others done in the same period is his use of broad washes and loose, but descriptive, brushwork. Unlike many Victorian watercolor painters, who built up each element of the picture with tiny brushstrokes in a semi-stippling technique, Homer worked with a heavily loaded brush, laying in broad areas of color, and layering colors over one another with broad strokes of the brush to build up forms or exploit the play of light on landscape or water.

Brushwork (below)
There is no attempt at precise detail in the treatment of these trees, yet the brushwork is both descriptive and expressive. The distant trees have been painted over the light gray used for the hillside, with the first color allowed to dry first, to give crisp edges. In the nearer group, colors have been allowed to run together slightly in places.

Texture (left)

The uneven texture of the rocky mountains has been suggested by deliberate slight blotches, produced by working a light and dark gray into one another while still wet. These washes were left to dry before the darker gray and touches of green were added, because a sharp edge was needed here to divide the distant mountain from the nearer one.

Building up colors (right)

Considerable depth of color has been achieved both by working one color into another wet in wet (the deep red-brown on the extreme left) and by overlaying colors wet on dry. On the right you can see a slight speckled effect, the result of dragging the paint over dry paper so that it catches only on the top grain.

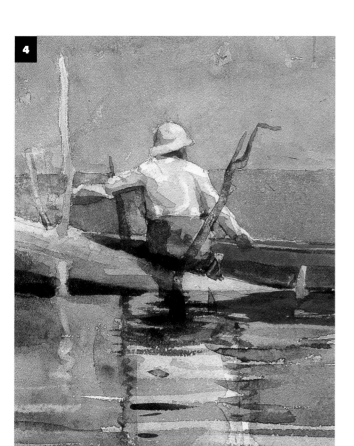

Lights and darks (above)

On the figure, the highlights, such as those on the shoulder and arm, have been reserved as white paper, and the folds of the shirt described with just a few brushstrokes of light brown and gray. The blue water behind the boat was produced with one wash of strong color, and the boat was begun with a yellow wash, overlaid with one application of red-brown, mixed with the minimum of water.

Lifting out (above)

These pale shapes where the clouds reflect in the water were made by first laying a light, pinkish base wash, then painting blue over it and lifting it out (see p. 83), probably with a damp brush, giving soft edges.

TUTORIAL: Figures in Landscape

Many amateur painters are daunted by the difficulties of painting people, and so edit the figures out of their landscapes, but this is a pity, because a figure or two can add to the atmosphere and provide a touch of narrative interest. In pictorial terms, figures can also give a sense of scale or provide either a focal point or some foreground interest. Michael Chaplin decided that, for all these reasons, foreground figures were needed for his painting "In the Alps," and he drew on a visual reference file of color sketches. He is painting on stretched, cold-pressed (Not-surface) Bockingford paper, and uses high-quality sable brushes, vital to his loaded-brush method.

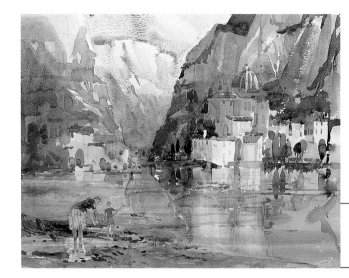

In the Alps,
by Michael
Chaplin

COLORS USED

Alizarin violet

Cobalt blue

Burnt umber

Emerald green

Cadmium yellow

Burnt sienna

Ivory black

Cerulean blue

Brown ocher

Yellow ocher

TECHNIQUES USED

Brushwork	page 80
Lifting out	page 83
Washes	page 90
Wet in wet	page 92
Wet on dry	page 93

**1 Working from sketches
(above and right)**
The composition of the painting is loosely based on this very rapid pencil sketch, with the figures brought in from a selection of color studies of people in various postures. For anyone who habitually includes figures in landscapes, visual reference—sketches or photographs—is very helpful.

2 Letting the painting grow (left)
Only the faintest of underdrawings has been made, because the artist likes to have the freedom to make changes as the painting develops. As can be seen, this one quickly began to depart from the pencil sketch. Working with a fully loaded, "one-touch," flat sable brush, he lays a light red-brown wash, followed by a darker one that he takes carefully around the white building. The board is tilted, so that the color runs down to form dark pools at the bottom of the wash.

3 Watercolor effects (right)
The cobalt blue used for the sky was mixed from raw pigment by the artist, because he likes the granulated effect produced by this home-made color. Another effect he will make use of, this time accidental, is the run of color where the brown wash has flowed into an earlier, very pale color.

4 Light against dark (above)
The white buildings set against the dark hillside are to be the main focal point of the painting, and it is important to establish the tonal contrasts at an early stage. Deep blues have been brought into the hill on the right, and the artist now begins to work on the building, using a diluted version of the red-brown mixture.

5 Suggestion (right)
The artist continues to work on the buildings, placing the washes accurately and keeping the lines vertical, but avoiding any precise definition. Throughout the painting, the landscape features are suggested, rather than described literally.

6 Economic brushwork (left)
What gives the painting its freshness and sparkle is the economy of the brushwork; two strokes are never used where one will suffice. Each of the trees, for example, consists of one shaped brushmark, made with a large, pointed sable brush fully loaded with paint.

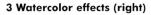

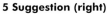

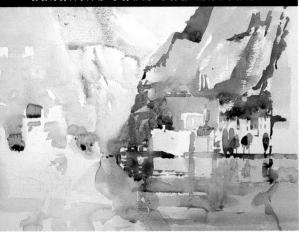

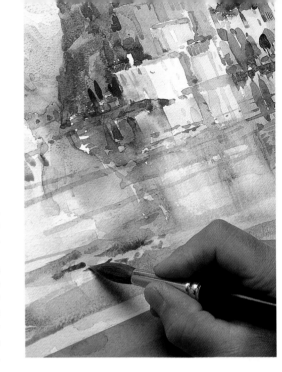

8 The foreground (right)
The artist begins to establish the general structure of the foreground which will form the framework for the figures. Once these colors and tones are established, he will be able to judge those needed for the figures. To unify the composition, he uses similar red-brown mixtures to those on the roofs and hillside.

7 A compositional key (above)
So far, the artist has concentrated on the right and center of the picture, because this area, with the vertical of the buildings carried through in the reflections, provides the key to the composition. He can now consider the foreground, its figures, and the area behind.

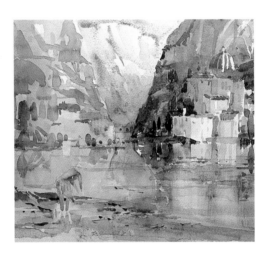

10 Making decisions (left)
With the main figure in place, the artist now decides to introduce another, that was not in his sketch. This will strengthen the narrative interest in the foreground and allow him to bring in a further color.

9 Setting the figures (above)
A light drawing was made earlier, to place the figures roughly and enable him to work around them. Now he refers to his color sketch and draws in the main figure more precisely, making a light outline with a very sharp pencil.

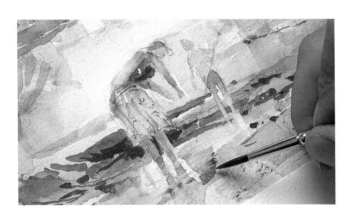

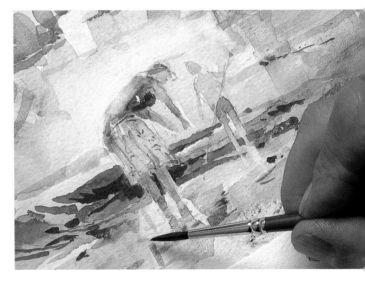

11 Lifting out (above)
The darker areas of the boy's body have been painted over the light colors of the water, but for the pale legs and reflection it was necessary to wash out a little of the red-brown with the tip of a damp brush. The earth colors lift very easily, because they sit on the surface of the paper without staining it. The highlight on the woman's back has also been produced by lifting out.

12 Avoiding detail (above)
The figures are treated very loosely and with the minimum of detail, so that they do not stand out too strongly and take attention from the main center of interest. Final touches are made to strengthen the tonal contrasts around them, and to add more red to the boy's body.

The finished picture was worked loosely and freely throughout, and by giving no special emphasis to the figures, the artist has fully integrated them into the landscape. Their obvious absorption in their holiday pursuits adds atmosphere to the scene, and brings in a storytelling element seen in many paintings that include figures.

Suggesting shapes
The brushwork has been used very cleverly to suggest the tree-clad hill without describing it in detail. Several layers of shaped brushstrokes have been worked over one another wet on dry.

Special effects
The way the paint has granulated in this area adds a touch of additional interest. This is an effect that many watercolor painters deliberately induce. Notice also how the top of the mountain has been defined by letting the painting run down to form darker pools at the bottom of the sky wash.

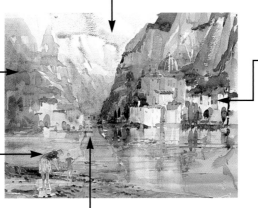

Crucial detail
Detail has been used sparingly but tellingly on the buildings, with a few dark, horizontal brushstrokes describing the tiled roofs, and small, roughly vertical marks suggesting the shape and proportion of the windows and the way they are set on the face of the walls.

Color links
In the final stages, the boy was given a red T-shirt, to bring in an accent of warm color and to provide a more obvious link with the red roof on the left. The color of the woman's upper garment repeats the blues used on the hillside.

Using accidental effects
Here, you can see how an accidental effect, where paint ran down the paper in the early stages, has been turned to advantage, making a shape that runs down the center of the water from tall mountain to foreground.

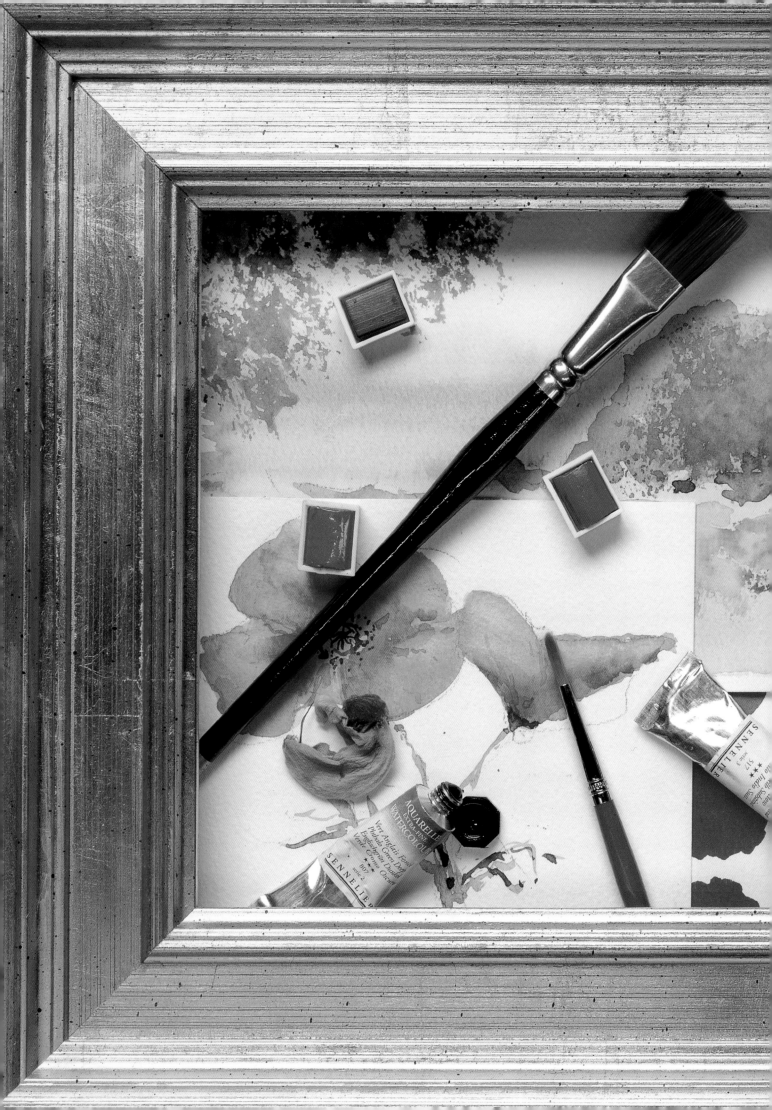

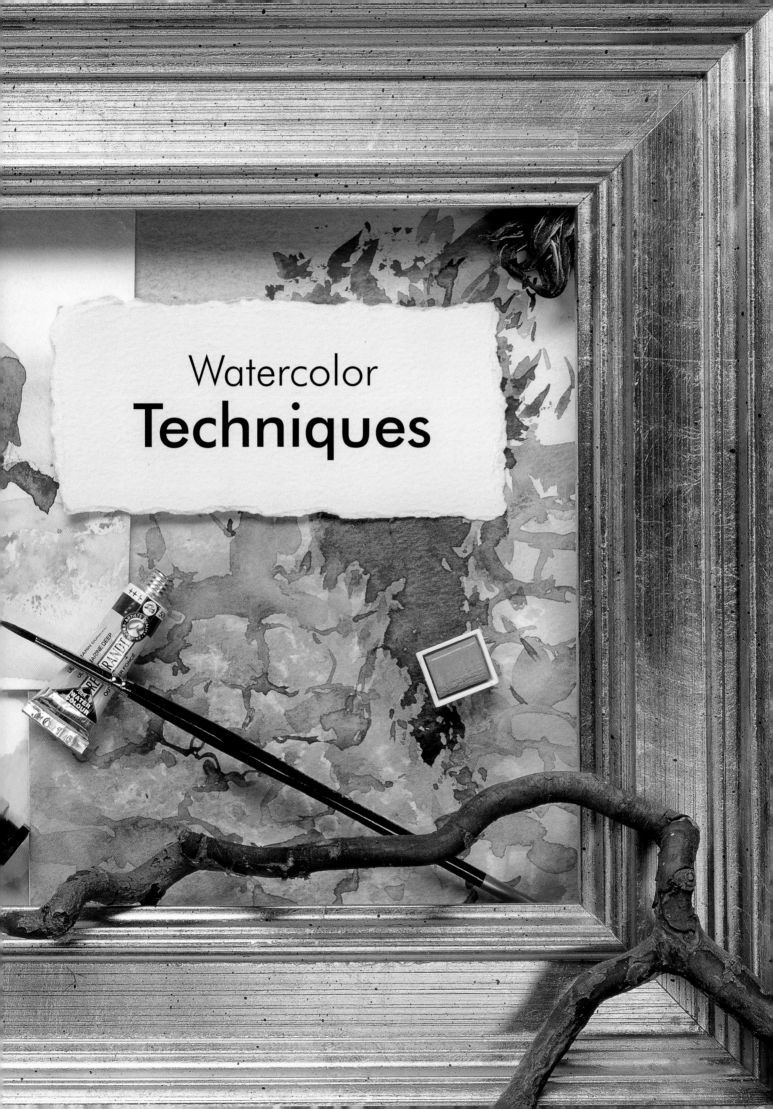

Watercolor
Techniques

Watercolor Techniques

This section focuses on the methods used in watercolor work in both past times and the present day. Those new to the medium will find the step-by-step demonstrations easy to follow and instructive, while more experienced painters may discover new tricks of the trade.

BACKRUNS

These are among the accidental effects in watercolor work that can be a disaster, but they can also be encouraged and used to advantage. Unwanted backruns are usually the result of trying to work into a wash (see washes, p. 90) before the paint has dried. If there is more water in the new paint, the semi-dry color will "run away" from it, causing blotches or cauliflower shapes. These can suggest forms, and are often deliberately induced to suggest clouds, foliage, or flowers, or simply employed to enliven an undefined area of background.

Color into color

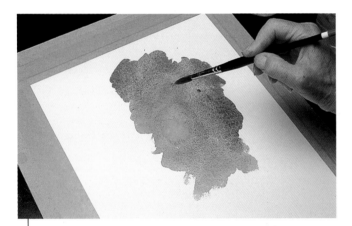

1 The effect of backruns depends on the water content of the paint. The red and the blue are about the same strength, so they have run into one another without creating a backrun, but the yellow has more water in it, so the paint has begun to flow outward.

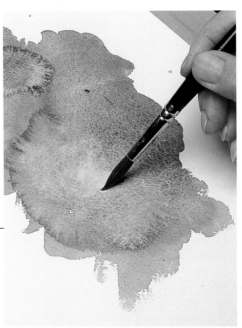

A little watery paint has been **2** dropped into the blue at the top, and more yellow in the center, and the backruns begin to form. The paint will continue to move until dry.

Water into color

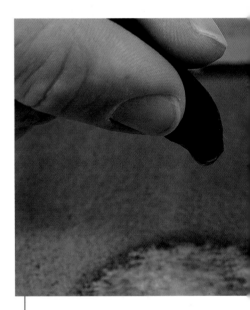

1 You can make dramatic backruns by simply dropping clean water into wet paint; the more water the larger the backrun.

2 This cluster of backruns is exciting in itself, but the method can be used descriptively, for foliage or flower heads, for example.

BLENDING

This describes the smoothing together of colors and tones so that there is no discernible boundary between them. To achieve the carefully controlled blends you might require when modeling the features in a portrait or painting a detailed flower study, the best way to work is to start with a base wash and then lay on small brushstrokes of darker, rather dry color (see also dry brush, p. 80) and merge them together with a just-damp brush. Blending can be facilitated by adding a little gum arabic (see p. 17) to the paint, to give it more body and prevent it running.

Looser, less controllable blends can be achieved by working wet in wet (see p. 92), but the paint is likely to form random hard edges as it dries or to run where you don't want it to, so this technique is more suitable for larger areas.

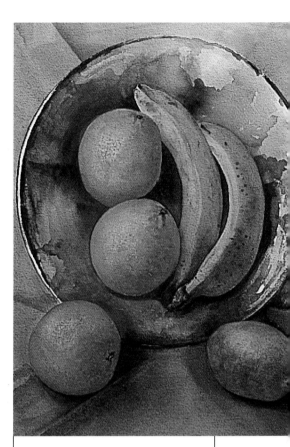

Bowled Over,
by Doreen Bartlett
The very controlled blends on the fruit have been achieved by working with the minimum amount of water, and letting the paper dry between stages.

1 The artist begins by laying almost flat color over the whole area, softening the edge of the top petal with a damp brush.

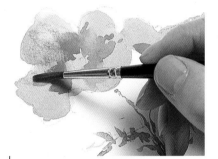

2 She then builds up the depth of color gradually. As the subject demands, she leaves some edges hard, and softens others by gently smoothing the new colors into the earlier ones.

BODY COLOR

This simply means opaque paint. In exhibition catalogs you will sometimes see a watercolor or gouache painting described as "watercolor with body color." Watercolor can be mixed with white gouache to thicken it and lessen its transparency, or white gouache can be used on its own for soft highlights.

When using opaque watercolor or gouache, it is most effective to reserve the thicker paint for pale colors, leaving the darker ones transparent—either pure watercolor or thinned gouache.

Gouache is used for this portrait study, and in the early stages it is diluted with water so that it is more or less indistinguishable from water color. **1**

2 Gradually the paint is given more body by mixing the colors with white. The thicker paint is reserved for the highlight areas, such as those on the white girl's face.

BRUSHWORK

Some watercolors are built up in a series of flat washes, with the marks of the brush barely visible, but in others brushwork plays as large a part as it does in an oil painting. The watercolor painters of the 18th and 19th centuries placed considerable emphasis on brushwork and would paint foliage and other landscape features with many separate individual marks. Some modern watercolorists still work in this way, while others make looser, more calligraphic marks.

Get to know your brushes and the various marks they can make by practicing on an inexpensive sheet of paper. Vary the pressure so that the paint is drawn out toward the end of the stroke, and try twisting the brush so that the stroke is not uniform in shape. Also experiment with different hand positions: holding the brush near the end of the handle gives a loose, free stroke, while holding it near the ferrule allows maximum control but can result in tight, fussy-looking work.

The Spirit of Winter,
by Margaret Martin
The economy of the brushwork is striking: each hill, shadow, or clump of foliage has been created with little more than a single stroke.

1 Several brushes are to be used, each chosen according to the task it is to perform. For the buildings, a hake brush is ideal.

2 An unusual but clever choice is a household brush, which the artist has splayed out to create the ragged effect of the tree edges.

3 The long-haired, pointed brush used for the fine detail is very flexible, which prevents the work from becoming too tight and fussy.

4 Large, pointed sable brushes can produce a variety of marks, from bold, rounded shapes to the fine lines used for this window

DRY BRUSH

This is a technique common to all the painting media, involving working with the bare minimum of paint on the brush. There are two slightly different uses of this method in watercolor work. One is a way of building up tones and colors by shading, rather as you would in drawing. Here, an overall wash is laid first, and then small amounts of paint are picked up with the point of a just-damp brush and worked with separate brushstrokes, growing progressively darker or more vivid.

The other method is useful for textured effects, such as foliage or grass in a landscape. A small amount of paint is picked up on the end of a square-ended brush with the hairs slightly splayed, resulting in a series of fine, roughly parallel lines. The effect can be varied by working one color over the top of another, with the brushmarks following different directions.

Gouache

A slightly different use of the dry-brush method can be helpful for gouache painting. Gouache paints are easily soluble, and it is easy to muddy the colors when building up in layers of opaque paint, because each new application melts the one beneath. You can avoid this by using stiff, rather dry paint, picking up just a little at a time on the end of a bristle brush and taking it lightly over the earlier colors.

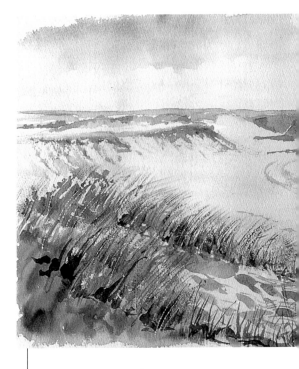

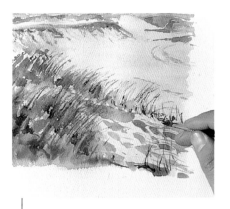

1 A fine, pointed brush is dipped into paint, partially dried, and pulled over the paper to produce broken lines for the grasses.

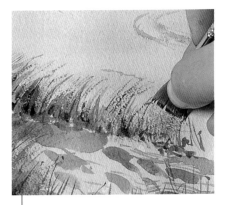

2 To increase the density of the grass, a large flat brush is used, with the hairs splayed out to create a series of close lines.

3 In the final stages, fine lines of white highlight on the grasses were created by the scratching-back method (see p. 87).

GLAZING

This is a term that causes dispute among watercolor painters; some believe that the word "glaze" should be restricted to the type of shiny, transparent, color overlay used in oil and acrylic painting, and, of course, in ceramic work. However, you are likely to come across references to watercolor glazing in books or art classes, so it is worth explaining what it means. A glaze is simply a wash of color (see washes, p. 90) laid over an earlier dried color, either to amend it or to give it more depth. You might find that an area of a painting, for example a blue sky, needs to be "warmed up" and given more intensity, in which case you could take a blue-purple glaze right over it. Take care with overlaid color, because there is a risk of the new layer disturbing the color beneath; to reduce this risk, sweep a large, soft brush swiftly over the paper.

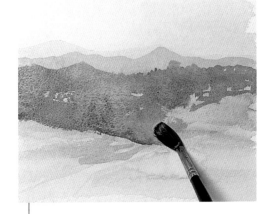

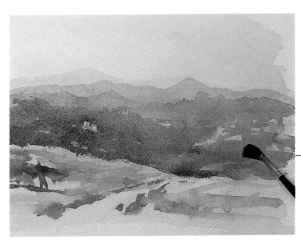

1 Flat washes have been laid over the whole of the hill area and allowed to dry before a darker glaze is taken over the nearer hill. The artist works quickly, sweeping a loaded brush from left to right.

2 With the foreground complete, the hills seemed too pale to provide contrast, so the area was again glazed, with a touch of green mixed into the blue-gray used previously.

IMPRESSING

Surface patterns can be made by pressing a variety of materials, such as rough-textured fabric, into wet paint. If the paint is left to dry or partially dry before removing the fabric, the imprint will remain in the paint. A version of this method is to lay plastic kitchen wrap over a wet wash. The film will crumple as you lay it, rather than going down flat, and when removed will leave a random pattern of irregular triangles, squares, and broken lines. You can control the effect to some extent by crumpling the wrap in advance, for example making a series of folds or pleats will give a linear pattern that could suggest tree trunks, or the stems of flowers in a vase.

Using plastic wrap

1 A wider variety of effects can be achieved with plastic wrap (cling film), depending on how you crumple or fold it and how long you leave it in place. Here, the artist makes small pleats with his fingers.

2 When the wrap is removed you see a pattern of small dark pools and lighter lines which could suggest a number of textures in the real world.

Using fabric

1 Colors roughly suggesting a landscape are laid loosely onto the paper, and rough fabric is pressed into them while still wet.

2 The fabric is removed, leaving an interesting random texture that could suggest old, crumbling brick or stone.

INDENTING

Sometimes a painting will call for unobtrusive dark lines. Examples could be the pattern of tree bark, or a suggestion of brick- or stonework on a building. These can, of course, be painted with a brush, but an alternative method is to "draw" them into wet paint with a pointed stick or the end of a paintbrush. By doing this you will be making a small valley into which the paint will flow, thus creating a line that is darker than the surrounding color but does not stand out as strongly as a brush-painted line.

1 This method has obvious practical applications, and is very easy to do. For tree bark, first lay on the colors and make sure that they are right, because you won't be able to work over the indented area to any extent.

2 While the paint is still wet, draw into it with a pointed implement such as a knitting needle; avoid sharp points or you may damage the paper. You can use the indenting technique for linear details as well as texture, for example the veins in leaves, grasses, or small twigs.

Vegetable Still Life,
by John Lidzey
In this sketchbook study, the softer
highlights were produced by lifting
out dry paint. The sharp highlight
on the aubergine was reserved as
white paper.

LIFTING OUT

One of the trickier aspects of watercolor work is "painting" white, particularly soft-edged white shapes, such as clouds. In classic watercolor technique, whites are reserved by painting around them, but this results in a hard edge; an alternative method is to lay a wash and then lift out parts of it while still wet. A small natural sponge, or pieces of absorbent cotton (cotton wool), or paper towels can all be used for this method. Crumpled paper produces a very realistic cumulus-cloud effect, because it lifts the color unevenly, leaving small patches of the wash behind. For wind-clouds, try wiping across the wet wash with a small piece of absorbent cotton.

Two-color effects

Dry watercolor can also be lifted out, to soften edges and create diffused highlights, but it is not always possible to get back to pure white paper. However, this can be used to advantage, because you can create intriguing effects by lifting out one color to reveal another. Gum arabic is an invaluable aid for this method. If you add a small amount of gum to the second layer of paint and lift it out with a small damp sponge, cotton swab, or wet brush, the paint will come away cleanly, because the new water melts the gum arabic.

2 She then paints first a pale and then a dark gray over the clouds, and lifts out small, soft-edged shapes at the bottom with the point of a damp brush. Finally, she creates a dramatic, sunlit edge by drawing into the paint with a rag wrapped around a brush handle.

1 The artist begins by laying a blue wash over the sky area and then lifts out the shapes of the clouds with a piece of crumpled tissue.

Like all watercolor techniques, lifting out **3** needs practice, but it is fun to experiment with, and once you learn how to control the method you will find you can create highly realistic cloud effects.

LINE AND WASH

In the early days of watercolor, the paint was sometimes used merely to add color to a pen and ink drawing, but the method later developed into a more integrated approach, where the line and color complement one another.

Most contemporary artists regard the "colored-in drawing" effect as undesirable, and some will work with water-soluble ink, using this and watercolor washes hand in hand so that the wet paint softens the line in places. In general, it is best to avoid starting with a complete pen drawing; instead, begin with some line and then color, and add to both as the work progresses. You can even leave the linear drawing to the final stages, using it to add a touch of definition to an almost-complete painting. For this approach, you may achieve a less obtrusive effect if you use a dip pen with a strong solution of watercolor rather than black ink, which may stand out more strongly than you wish.

1 For a complex subject like this, it is wise to begin with a pencil underdrawing. Once you begin to use the pen and ink you will not be able to erase.

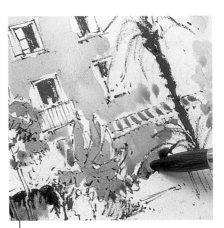

Mission Santa Clara, by Claire Schroeven Verbiest The artist has used less pen and ink and a lighter line than in the demonstration below, restricting it mainly to touches of fine detail.

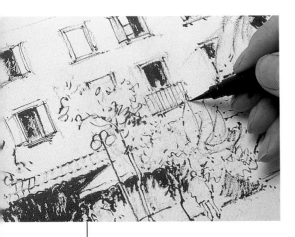

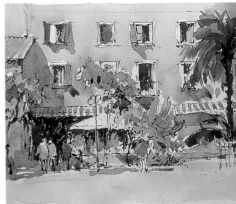

2 Using a fine, fiber-tip drawing pen, the artist sketches in the scene. He fills in the dark areas as solid black, because watercolor cannot produce this strength of tone.

3 The watercolor is applied loosely over the lines, using a large, well-loaded brush.

4 The advantage of this technique is that the pen and ink work provides the basic drawing and structure, as well as much of the detail, enabling you to paint freely.

Liquid frisket

1 Liquid frisket (masking fluid) has been painted on and allowed to dry, and a wash is laid over it.

2 After laying another wash on the nearer area of sea, the liquid frisket is removed by rubbing with a tissue.

MASKING

In watercolor work, highlights are reserved as white paper by taking color around them. It can be tricky to retain clean highlights throughout the build-up of a painting, and some watercolor painters protect them by masking them out with a viscous substance called liquid frisket (masking fluid). This can be doubly helpful, because it allows you to work freely, exploiting loose washes (see p. 90) and wet-in-wet (see p. 92) techniques without the worry of paint splashing over the edges of a white area. The fluid can be removed at any stage in the painting, and can thus produce pale-colored highlights as well as pure white. If you peel it off at a halfway stage and then build up further washes over the picture, the once-masked areas will remain lighter than the surrounding areas.

For straight edges, such as the walls of a white or pale-colored building against a dark background, masking tape is better than the fluid, which is difficult to apply in perfectly straight lines. Tape may not work well on very rough paper, however, because it will adhere only to the raised grain, allowing paint to seep in under the edges.

Masking tape

1 This subject requires straight lines with clear, precise edges. Preliminary washes have been laid on and allowed to dry before masking tape is stuck on very carefully.

2 Because he does not have to worry about the lines becoming crooked, or paint slopping over the edges, the artist can use a large brush, well loaded with paint.

MIXED MEDIA

Although many artists find that producing a good painting in pure watercolor is the ultimate challenge, there is no reason why you should restrict yourself to one medium, and you may find mixed-media approaches more satisfying. Watercolor can successfully be mixed with the other water-based paints—gouache and acrylic—as well as with watercolor and acrylic inks, but there are other combinations that work well. Pastel painters sometimes begin with a watercolor or acrylic underpainting, and you can take this idea further and use watercolor and pastel together. The contrast of textures creates exciting effects.

Oil pastel can also be combined with watercolor, but remember that oil and water do not mix, so if you try to lay watercolor over oil pastel it will slide off (see wax resist, p. 92). This can be very effective, provided you know what you are doing and plan the painting accordingly. Because there are no fixed rules, any mixed-media work requires practice and a period of trial and error, so you might find it helpful to use a failed watercolor as a test, or simply doodle to try out different ideas.

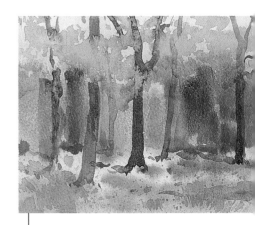

1 Watercolor is to be combined with pastel for this woodland landscape. Because watercolor is a wet medium and pastel a dry one, the painting is done first and allowed to dry.

2 The darker colors are allowed to stand as pure watercolor, with the pastel used mainly for the highlights, and to provide accents of color in the foliage.

3 The artist wants to draw the eye toward this area of the painting, and lays pale mauve pastel over the darker watercolor to suggest distant tree trunks.

Onions
by Keith Andrew
For this powerful painting,
watercolor and gouache are
combined, so that thick, opaque
paint contrasts with fluid,
transparent washes.

SALT SPATTER

This is one of the most exciting ways of creating texture and surface interest, or both. If you scatter crystals of rock salt into a wet wash, they will gradually absorb the paint, drawing it in to each crystal, to leave a lovely snowflake shape when dry. The effects vary, according to how wet the paint is and how thickly or thinly the crystals are distributed, so you will need to experiment. It is also time-consuming, because the salt takes time to dry, but the end result makes it worth waiting for.

1 The artist has laid a variegated wash, working wet in wet, and now scatters salt into the still-wet paint.

2 Many different effects can be achieved, depending on how much salt is put on. In this case a good deal has been used, and it has been spattered closely.

3 It can be difficult to find a practical application for this "fun" technique, but here the artist has cleverly integrated the spatter into the landscape.

SCRATCHING BACK

It can be difficult to achieve fine linear highlights in watercolor work, or the small points of light you might see on the surface of ruffled water. Liquid frisket (masking fluid, see masking, p. 85) is too thick and rubbery to paint on in thin lines or tiny dots, and obviously it is not possible to reserve these highlights by painting around them. The solution is to use a sharp knife, such as a craft knife, to scratch into the paint and reveal the white paper. This should be done only in the final stages of a painting, because it scuffs the paper and makes it impossible to apply more paint on top, and the paint must be completely dry. The paper should also be reasonably heavy, not less than 140lb (300gsm) (see p. 14), or you may make holes in it.

1 This method is ideal for creating small points of light on water or foreground foliage. A dark blue wash is laid and left to dry.

2 A knife is used to scratch away the paint. You may scuff the surface of the paper slightly, but this does not usually matter, because scratching back is always done in the final stages of the painting.

SPATTERING

This is a method of flicking or spraying droplets of fluid paint onto the surface, usually over an existing color. In seascapes, opaque white is sometimes spattered over transparent washes, to depict the fine spray above the crests of waves, but more often the method is used in a less literal way, for example to give a suggestion of texture, or to create random splashes of color, such as you might see in a flowery field in the middle distance.

The most commonly used implement for spattering is an old toothbrush. This is dipped into paint, and held face down above the paper while you run your finger or a pencil along the bristles. For a coarser spatter, a bristle brush can be used, loaded in the same way, and tapped against the handle of another brush to release the droplets. A very fine spatter can be made with a plant spray or a mouth diffuser of the kind sold for use with bottles of fixative, but both these give a very even and rather mechanical effect.

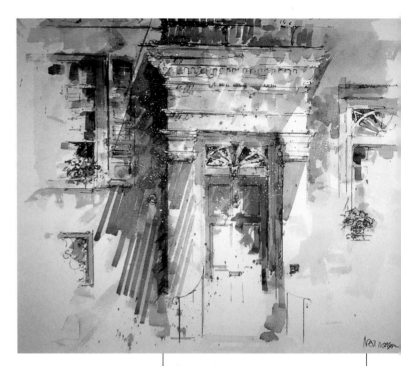

Study of a Doorway,
by Neil Watson
The tiny droplets of opaque white paint spattered over the top of the door and wall play no descriptive role, but add a touch of sparkle.

1 The artist intends to use the spattering method for the foreground only, and completes the rest of the painting first, so that he can judge how much is needed.

2 He masks the finished areas with tracing paper before spattering two layers of paint, the second one slightly darker than the first.

3 Sometimes spattering creates blobs or over-large droplets of paint. These can be removed with a piece of tissue.

TONED PAPER

White paper is most commonly used for watercolor, because the white reflects back through the paint to impart the characteristic luminous quality. But for a darker-toned painting where there are no white highlights, perhaps a land- or seascape at dusk, or for a predominantly opaque watercolor, it can be helpful to work on a toned paper. The 18th- and early 19th-century watercolor painters used ocher and light-brown papers to great advantage. Some art-supply stores sell toned papers, but if you cannot obtain them you can make your own simply, by laying an even wash of thinned acrylic paint over the paper. Avoid very dark colors; instead choose pale browns, grays, blue-grays, or creams, according to the color scheme of the painting.

SPONGE PAINTING

As mentioned earlier, sponges are useful for lifting out paint (see p. 83), but you can also use them to apply paint, using a dabbing motion. This is useful for areas of texture such as foliage, sandy beaches, or weathered rocks. You can build up considerable depth of color by sponging paint in layers. The only problem is that sponging creates an uneven, stippled effect that is very different to brush-applied washes, and the painting can look disjointed unless you take care. If this happens, consider leaving the painting to dry and then working into some of the washes with a damp sponge, so that the painting has a continuity of technique.

1 The artist has begun with light overall washes for the sky and land, and now sponges the foliage, building up the form with two layers of paint.

2 For the large tree, he has combined sponging with brushwork, and does the same in the foreground so that the painting has an overall consistency of technique.

Toned paper

1 For this gouache painting, the artist intends to leave much of the ground color showing, so she lays a warm red ground, darker at the top.

2 The greens are modified by the red of the ground, but the browns used for the tops of the mountains take on additional richness.

3 The artist continues to build up the painting with a series of separate brushstrokes, each carefully placed, and some worked wet on dry over earlier strokes.

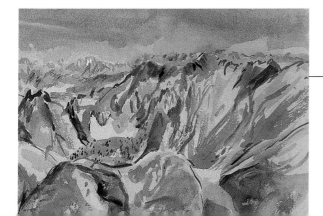

4 For most of the painting, the gouache has been used thinly, at watercolor consistency, but in the final stages a little opaque paint has been added to the top of the distant mountains and the sky.

UNDERDRAWING

For anything but very rapid sketches, it is important to make a pencil underdrawing before painting; this is a way of planning the composition, as well as making sure that the shapes and proportions are correct. If you use a fairly hard pencil, such as HB or B, and keep the lines light, the paint will cover them, but some artists like to incorporate the drawn lines into the composition, and make a heavier, more positive drawing. Whichever approach you take, draw outlines only, avoiding any shading. If you need to erase the drawing, make sure that you brush off any small bits of eraser left on the surface, otherwise the paint will pick these bits up.

1 The artist is using a sharp, but soft, pencil (4B) for the drawing. Soft pencils are easier to erase than harder ones such as HB, but the choice is largely a personal one.

2 Here, you can see the importance of the drawing. In a subject like this it is essential to plan the background wash, and to take it carefully around the edges.

3 Again, the outline drawing helps the artist to place the bands of dark and light color that explain the forms of the mugs.

WASHES

These are the basis of most watercolor work. A wash can cover the whole of the paper, or only a small part of it, but is usually defined as any area too large to be covered with a single brushstroke. Some artists begin a watercolor with an all-over wash, reserving any white highlights, or a landscape might be begun with two washes, one wash for the sky and another for the land area.

A wash does not have to be completely flat and uniform in tone, but it is important to maintain the freshness of the paint and avoid blotches and streaks, so washes over a large area must be laid quickly. You can use a large brush or a sponge, laying on the paint in a series of broad, slightly overlapping bands. Dampening the paper helps the paint to spread out evenly, but if you do this, dampen it only in the area where you want the color—the paint will stop flowing when it meets dry paper. It is important to remember this when you are taking a wash around the edges of an object or landscape feature that you want to leave white until a later stage.

Laying a flat wash

Working on dry paper, with the board tilted at a slight angle, the brush is taken across from left to right. Each new band of color slightly overlaps the one above.

Wash variations

Skies become paler at the horizon, so you will need to lay a graded wash that varies in tone. This involves adding more water for each successive band of color. You can control the gradation quite precisely by dipping the brush into clean water before picking up the color, so that the wash is diluted by the same amount each time. For a more dramatic gradation, dip the brush in water twice, or even use water alone for the second band. Do not dampen the paper when using graded washes, or the bands of different strengths will flow into each other, evening out the tones.

Certain subjects may require a wash that varies in color, either evenly or randomly. For a random, variegated wash, further colors can be dropped into a flat wash wet in wet (see p. 92). For a precise color gradation, for example an evening sky with blues gently fading into greens and yellows, mix up the wash colors separately and lay bands of each in turn. In this case it is helpful to dampen the paper; it is difficult to avoid a stripy effect on dry paper.

Working around edges

There are two ways of laying washes around complex edges, as you might need to do for a sky. One is to dampen the paper only where you want the wash to go, and the other is to turn the board upside down and paint the edges first, as here.

Using a sponge

1 Some artists prefer a sponge to a brush for laying washes. In this case, the paper has been dampened all over with clean water, also applied with a sponge.

2 When you sponge on the paint, you apply slightly more pressure than with a brush, and this prevents the paint from running down the wet paper.

3 The slight striped effect visible while the wash was being applied has now disappeared, and the wash has dried completely flat.

Variegated wash

1 Many subjects, especially landscapes, call for a wash containing more than one color. Before you start, mix up all the colors and test their strength on a piece of paper.

2 If you want the colors to blend into one another, dampen the paper first and then lay successive bands of color, washing the brush between each one.

3 With the paint still wet, you can see the separate colors distinctly, but they merge as they dry. If you prefer a less blended effect, work on dry paper.

WAX RESIST

A resist is something applied to the surface to prevent the paint from reaching it. Oil (wax) and water are antipathetic, so if you scribble on the paper with a household candle before painting, the paint will slide off the wax.

Wax resist is an ideal method for suggesting textures, such as crumbling rocks, or the broken surface of water, which can pose a problem with a fluid medium. The effect will depend on the pressure applied and the texture of the paper: lightly applied wax on rough or Cold-pressed (Not) watercolor paper will sit only on the top grain and allow the paint to settle in the "troughs," resulting in a random, speckled effect when the color is applied. On smooth or Hot-pressed (HP) paper the resist will be more complete, as it will if you apply the wax very heavily.

Other suitable materials for resist are wax crayons, oil pastels, and oil bars. A transparent, colorless oil bar is especially suited to the method, because it is softer and easier to apply than candle wax, and you can scratch into it or scape away areas if desired before adding more color.

1 Colored wax crayons are used with watercolor for this flower study, and the artist begins by drawing the leaves lightly with green, and the flower centers with pale yellow.

2 She now lays on watercolor, which lies only in the non-waxed areas. Where the wax drawing was light, a little paint lies around the crayon marks.

In this detail of the finished **3** painting, you can see the full effect of the method, which provides an attractive contrast of textures.

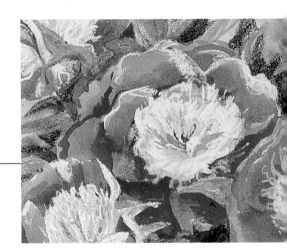

WET IN WET

This is a standard watercolor technique, in which colors are laid into and over one another while still wet. If you drop a new color into a still-wet wash, the weight of the water forces the first color outward, so the colors will bleed into one another but will not actually mix. It takes some practice to be able to control this method, and it is always unpredictable to some extent, because the paint continues to move until it has dried.

Most watercolorists make use of wet-in-wet methods at certain stages of a painting, or in specific areas. Some will start the whole painting in this way, wetting the paper all over before laying on colors. Others will combine wet in wet with wet on dry (see opposite), dampening the paper only in selected areas. The paint will not flow onto dry paper, so you can control the edges of a wet-in-wet shape quite precisely. Flower heads are often painted in this way.

Selective wet in wet

The flower heads are to be worked wet in wet, but the paint must remain within clear boundaries, so the paper is dampened carefully with a brush in these two areas.

Controlling the paint flow

1 A series of wet washes has been laid on well-dampened paper, and the board is held at an angle to encourage the paint to flow outward.

2 The jagged edge of the mountain was achieved by laying down gray paint, tilting the board upside down, and then laying it flat to halt the flow of the paint.

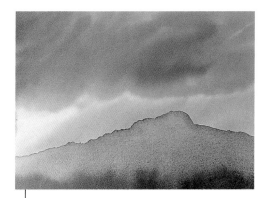

3 Compare this photograph with step 2, and you can see how the paint keeps on moving until it has dried. The darker brushstrokes on the mountain are now lost.

Jerusalem,
by Robert Wade
This painting shows a
controlled use of wet in wet,
restricted to certain areas.

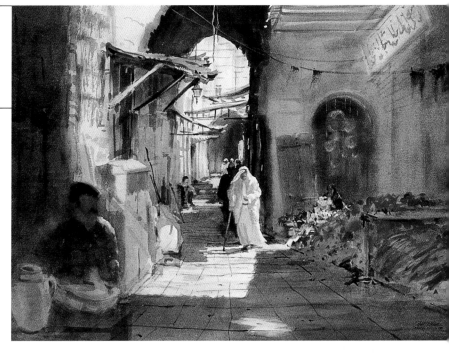

WET ON DRY

In classic watercolor technique, paintings are built up gradually from light to dark by laying successive washes (see p. 90) or brushstrokes over paint that has been allowed to dry. The main characteristic of wet-on-dry work is the crisp, hard edges formed as each wash dries. Some painters dislike this "edginess," but others exploit it to give an extra dimension to their work. The Cotman painting on p. 20, shows how flat, hard-edged planes can form a vital element in the composition.

1 Although the painting has a fresh and spontaneous feel, the artist works methodically, drying the paper between each stage.

2 The shadows are painted with a well-loaded brush, so that small pools of paint collect at the bottom.

3 The wet-on-dry method suits the busy, sunlit scene very well, giving a crisp edginess to the image.

Index

Illustrations of completed pictures are indicated by *italics*. Where these are part of a tutorial the reference includes '+ SSD' (Step-by-Step demonstration). SSD in parentheses following a page reference indicates a Step-by-Step demonstration of a technique.

Credits

Quarto would like to acknowledge and thank the following for pictures appearing on the pages given below

British Museum: 20–1; Christie's Images: 10, 68–9; e.t. archive: 11 tl; Victoria and Albert Museum: 28–9; Visual Arts Library: 36–7, 44–5, 60–1.

Key: t = top l = left r = right

All other pictures are the copyright of Quarto Masterstrokes Watercolor credits

Quarto would also like to thank the many artists who have contributed their work to this book, and in particular the following artists who performed the step-by-step tutorials:

Glynis Barnes-Mellish
Michael Chaplin
Adalene Fletcher
Kay Ohsten
Alan Oliver
Jason Skill